THE PRE-RAPHAELITES

THE
PRE-RAPHAELITES

Andrea Rose

For my Father

The author wishes to thank Diana Eccles, Jeremy Maas,
and Mrs Imogen Dennis

Phaidon Press Limited
2 Kensington Square, London W8 5EP

First published 1977
This edition, revised and enlarged, first published 1981
Fourth impression (with corrections) 1992
Fifth impression 1992
Sixth impression 1993
This hardback edition first published 1994
© Phaidon Press 1992

A CIP catalogue record of this book is available from the
British Library

ISBN 0 7148 3240 5

Printed in Singapore

Cover illustrations:
(front) John Everett Millais, *Lorenzo and Isabella*, 1849 (Plate 3);
(back) Edward Burne-Jones, *The Arming of Perseus*, 1877 (Plate 45).

The Pre-Raphaelites

Among the more incredible pieces on show at the Great Exhibition of 1851 was a taxidermist's tour-de-force, *The Ermine's Tea Party*. A company of stuffed animals sits round a table laid with miniature teaplates, cakestands and teacups and, with all the anxious civility and smiling bonhomie of a human party, one pours tea for another, the sugar bowl is passed, another demurs before a plate of dainty cakes. Everything from the watchchains looped across the furry fronts of the males to the cambric-trimmed petticoats of the females is utterly life-like. Not an illusion is spared. The whole ensemble is a masterpiece of realism. By 1851, three years after the Pre-Raphaelite Brotherhood had been formed, realism was the prevailing temper of the country. It could be seen not just in the attempts by artists and craftsmen to make every product that issued from their hands thoroughly naturalistic — that is, as like nature as possible (witness the curtain hooks made of brass harebells or the corn-handled bread knives of the Great Exhibition) — but also in the plain domestic setting of Victoria's court, in the journalistic adaptability of Tennyson, the poet laureate, and in the publication of such monumental surveys as Henry Mayhew's *London Labour and the London Poor* (1851-62), which the author intended as 'a cyclopedia of the industry, the want, and the vice of the great Metropolis'. Realism, or the Victorian faith in facts, was the pivot on which the consolidating mass of the bourgeoisie turned at mid-century to face a decade of unparalleled contentment and growth. At one angle of the turn, it produced such travesties of verisimilitude as *The Ermine's Tea Party*, where realism has been twisted into a grim imitation of life. At another, it encouraged men like John Ruskin, John Everett Millais, William Holman Hunt and William Morris to inject into their work a naturalistic accuracy appropriate to the age of science, and which was at odds with the soft-centred, woolly-edged products that passed for art among their peers and predecessors. For Prince Albert, at whose instigation the Great Exhibition had come into being, art was defined as 'lying somewhere between religion and hygiene'. For Ruskin, the great champion and apologist of the Pre-Raphaelite movement, however, art was infinitely more than that. 'The whole function of the artist in the world', he asserted passionately, 'is to be a seeing and feeling creature.' It was a call to arms, a challenge to artists to see themselves not merely as decorators or artificers, but as men responsible for communicating the integrity and the wholeness of life to a society rapidly being split by such rigid categorizations as 'work' and 'leisure', 'hand' and 'brain', 'profit' and 'loss'. It was a challenge that the Pre-Raphaelites, six of whom were students at the Royal Academy schools when the Brotherhood was formed, took up with all the enthusiasm and naïveté of youth.

The Pre-Raphaelite Brotherhood was founded in the autumn of 1848. As William Michael Rossetti wrote in 1901, its aim was no more specific than that 'an artist, whether painter or writer, ought to be bent

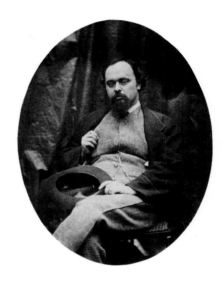

Fig. 1
Photograph of Dante
Gabriel Rossetti,
October 1863
Taken by Lewis Carroll.
Gernsheim Collection,
University of Texas

5

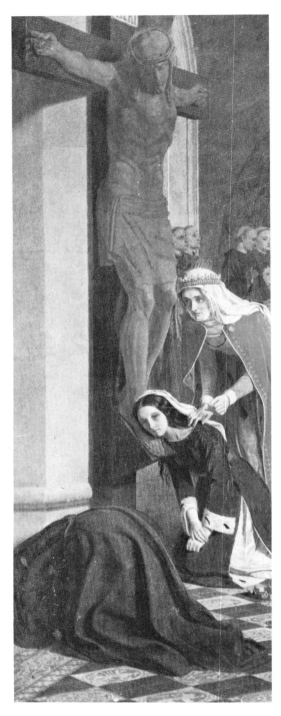

Fig. 2
James Collinson
(1825-81)
Detail from 'The
Renunciation of
Queen Elizabeth of
Hungary'
1848-50. Oil on canvas,
120.3 x 181.6 cm.
Johannesburg Art Gallery

upon defining and expressing his own personal thoughts, and that they ought to be based upon a direct study of Nature, and harmonised with her manifestations'. Of the seven founding members of the Brotherhood, only three are of serious note as painters: William Holman Hunt (1827-1910), Dante Gabriel Rossetti (1828-82) and John Everett Millais (1829-96). The other founding members were James Collinson (1825-81) whose High Church sympathies eventually led him to embrace Catholicism and to resign from the Brotherhood (Fig. 2); Thomas Woolner (1825-92), the only sculptor of the group, who, after emigrating to Australia in 1852 to seek his fortune in the goldfields, returned two years later to lead a moderately successful life as a conventional sculptor of portrait medallions and memorial groups; Frederick George Stephens (1828-1907), a painter of the slimmest talent who soon gave up painting to become an art teacher (at University College School) and the art correspondent of the *Athenaeum* (Fig. 3); and William Michael Rossetti (1829-1910), the prosaic, practical brother of Dante Gabriel and Christina Rossetti, who, despite his lack of creative ability (he was the only member of the Brotherhood not to have attended art school), brought considerable critical and scholarly gifts to the movement, acting as its assiduous secretary and historian.

The group met one evening at Millais' home at 83 Gower Street to look through a folio volume of engravings by Carlo Lasinio illustrating the frescoes in the Campo Santo, at Pisa, by Benozzo Gozzoli. They were ravished by the formal quality of the prints — the incisive outlines circumscribing flat, unshaded areas, the lack of conventional Renaissance perspective. They felt these qualities represented an antidote to all that was dismal and overblown in contemporary academic practice. It was a practice still grounded in the principles laid down by Sir Joshua Reynolds, first president of the Royal Academy, in his *Discourses on Art*. Reynolds' admiration for High Renaissance painting, which first flowered in Raphael and reached its full bloom in the seventeenth-century schools of Northern Italy, had fostered a tame school of British painters, well rehearsed in the handling of dramatic chiaroscuro, pyramidal composition, histrionic gesture, loose brushwork and standard Italianate landscape, but totally separated from the mental processes which had originally governed such productions. They were like versifiers in a foreign language. The precision and keenness of fifteenth-century art, at least as the Pre-Raphaelites saw it mirrored in the Campo Santo frescoes, cut through the rhetoric of this tradition. It recalled the diatribes of Rossetti's hero, William Blake, against the flabby handling of form he saw in the work of Rubens, Rembrandt and Reynolds. 'Filth', Blake had called it. The weapon he had urged for its removal was 'the wiry line of rectitude'.

So the Pre-Raphaelites saw the steely lines of Lasinio as a corrective. But the irony was that Lasinio's engravings were themselves reproductions of the original fifteenth-century frescoes. It was an irony that engraved itself as deeply on the forms that Pre-Raphaelitism was to take as the chiselled contours of Lasinio. For these reproductions were the catalyst for a movement that prided itself on 'absolute and uncompromising truth in all that it does, obtained in working everything, down to the most minute detail, from nature, and from nature only'. As such, it introduced the note of ambiguity that was to repeat itself time and time again within the annals of the movement. At the very outset, for example, the Brotherhood was deliberately limited to seven. It was not as if the founding members had such exceptional talents that no more could be found to swell the ranks. It was a deliberate attempt to be cryptic. The group that intended to reintroduce realism and a sense of commitment into art also held out for special treatment — an exclus-

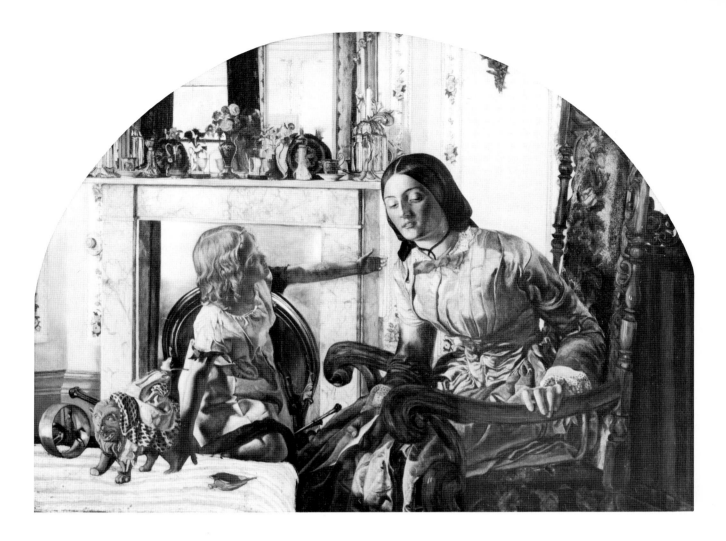

ive coterie who alone held the key to all realities. Rossetti in particular was partial to this form of symbolic gesturing. In one of his earliest published poems, 'The Blessed Damozel', seven stars adorn the hair of the heavenly maiden, three lilies are held in her hand. In the first painting he undertook as a Pre-Raphaelite Brother, *The Girlhood of Mary Virgin* (Plate 1), he placed a group of seven cypresses in the background of the painting, to the right of the aureoled dove, which itself is there to symbolize the Holy Ghost. According to Rossetti, the trees were supposed to represent the 'Seven Sorrowful Mysteries'. In fact, he must have confused the Seven Dolours of the Blessed Virgin with the Five Sorrowful Mysteries, but the point serves to illustrate his tendency to focus on the outward forms of religion as objects of aesthetic contemplation, without being too bothered by either the meaning of the symbols or the precise forms of the rituals.

In choosing to limit its number to seven, the Brotherhood was also perhaps consciously identifying itself with the Seven Sleepers, those mythical Early Christians who fell asleep in a cave, where they had fled to escape persecution by the Emperor Decius, and woke two hundred years later when the Roman Empire had become Christian. Whether the identification was conscious or not, the point is not far-fetched. If the Pre-Raphaelite Brotherhood had been formed by a group of serious-minded artists and writers simply wanting to express themselves more naturally than their predecessors, they would be yet another example of a 'Return to Nature' group. The path of cultural history is studded with such groups, ranging from the Caravaggists in seventeenth-century Italy to the Ash-Can school of New York in the

Fig. 3
Frederick George
Stephens (1828-1907)
Mother and Child
1845-50. Oil on canvas,
47 x 64.1 cm. Tate Gallery,
London

Fig. 4
John Everett Millais
(1829-96)
Caricature of a
Post-Raphaelite
Composition
c.1848. Pen and ink on
paper, 18.7 x 18.7 cm. City
Art Gallery, Birmingham

twentieth. But the origins of Pre-Raphaelitism belong within that deep-seated longing for a sense of wholeness to life which had been seeking expression since the 1830s, when the bright lights of the Romantic period — Byron, Keats, Shelley, Wordsworth, Coleridge, Scott, Turner and Constable — had dimmed to leave only a dark cast. 'Unity of feeling', wrote John Ruskin in 1837, then an eighteen-year-old gentleman commoner of Christchurch, 'is the first principle of good taste.' And it is this 'unity of feeling', in which the aesthetic sensibilities are riveted to the moral and imaginative bases of life, which the Pre-Raphaelites strove after. They hoped that by taking the simple piety they saw in early Italian painting and welding it to the uncluttered forms of those paintings — the precision of contours, the flatness, the naturalistic accuracy — they would similarly produce wholehearted works. But down this path lay a serious pitfall, one that led to the two directions Pre-Raphaelitism took. The ambiguity could be seen as the two faces of Pre-Raphaelitism: the one, a hard detailing of natural data, the other, a soft shaping of historical and archaic materials to form a romantic impression. In reality, these two seemingly irreconcilable faces are the opposite sides of the same coin. 'A technique always implies a metaphysic', wrote Sartre, and the metaphysic of the medieval period was fundamentally sacramental. Every aspect of life was seen to have a dual meaning, a spiritual and an earthly significance. Holy relics, for example, had supernatural powers; to make the sign of the cross could be a means of casting out devils in exorcism rites; words could be put together to make curses or blessings or forgivings and they could have sudden miraculous power. So it was too with the non-theological elements of life. The meanest flower, the smallest stone, was imbued with a sacramental significance. It was seen as a formal counterpart of the divine order of heaven. The works of art of the period, therefore, where object, symbol and idea fuse into one, have a natural wholeness to them, a satisfying unity which the mid-Victorian artist could but envy. But jealous as he might be, he could not hope to recapture that harmony. There was no betrayal in the medieval artist's image of reality between the visible world and the hidden spiritual world. For the mid-Victorian artist, however, the dual legacies of Protestantism and the mechanistic sciences had together successfully cleaved spirit from matter. By the mid-1850s, the gap between the facts of modern life and the provinces where the deepest human values lie was so wide that the bridges conventionally used to span the two — art and religion — were absurdly short. It became inevitable, therefore, that the forms of the medieval world should be no more than clothes-horses for the Pre-Raphaelite artist, on which he could hang a few colourful garments, a few arcane beliefs. At best, it could produce the bony structure for a viable archaeological reconstruction; at worst, the 'Wardour Street medievalism' of fancy dress. It was Ruskin who pointed out, in *The Queen of the Air*, that mythologies are most potent during the period that believes in them. It was in France, though, not in England, that the major new symbols of contemporary life were being permanently established as the stuff of modern life — the black frock-coats, the top hats, the boulevards and the race-tracks. 'Reality', as Carlyle affirmed, 'is the only genuine Romance for grown persons.' Much of the Pre-Raphaelite transcription of reality was an indication not of their insincerity but of their immaturity.

The 'heroism of modern life', however, to use Baudelaire's term, was another matter. When the Brotherhood met in the Gower Street drawing-room they produced no manifesto. Their sole code of operation was Truth to Nature. But what is Nature? Is it the woodspurge by the forest's edge or one's own inner nature — one's imagination and

feelings — sometimes as unnatural and as unreal as the chimera of the ancients? This question became the saw which split Pre-Raphaelitism in two, with Holman Hunt and Millais going in one direction, Rossetti in the other. But in the early stages of the movement, between 1848 and 1853, there was an identity of purpose that forced the disparate personalities of the group into a solid wedge against society. The issue they all agreed upon was the necessity to paint their own times. Behind their ambition to show plain, ordinary, everyday life was the belief that there existed an epic scale to modern life that was every bit as heroic as the trials of Laertes or the feats of the Round Table. They were not the first to feel this. Dickens had journeyed among the beadles and super-intendents of the government schools and found them fit material for his art. In so doing, the social dimensions of his art had automatically taken on a political importance, though Dickens was not writing 'polit-ical' novels. But Dickens had his critics, among them Walter Bagehot. Dickens' lowly characters, he asserted, are 'poor talkers, and poor livers, and in all ways poor people to read about'. He went on to say that 'the character of the poor is an unfit topic for continuous art'.

To say that the Pre-Raphaelites were political would be an exagger-ation, but they did not share Bagehot's view. They could not discount prostitutes, widows, foundry-workers, or even middle-class lovers from Hampstead from their view of reality because it would have made it partial, and they recognized the implication of living in an age of uni-versal suffrage, of democracy, and of liberalism. To deny the experi-ences of the lower classes space on the canvas would be to deny the very unity they sought. The philosopher and companion of George Eliot, G.H. Lewes, writing on *Realism in Art* in 1858, put the case eloquently:

> Realism is ... the basis of all Art, and its antithesis is not Idealism, but *Falsism*. When our painters represent peasants with regular features and irreproachable linen; when their milkmaids have the air of Keepsake beauties, whose costume is picturesque, and never old or dirty; when Hodge is made to speak refined senti-ments in unexceptionable English, and children utter long speeches of religious and poetic enthusiasm; ... an attempt is made to idealise, but the result is simply falsification and bad art ... Either give us true peasants, or leave them untouched; either paint no drapery at all, or paint it with the utmost fidelity; either keep your people silent, or make them speak the idiom of their class.

Such a passage helps one appreciate how much of a realist George Eliot was.

The theme of women's rights was much in the air in the 1850s. Holman Hunt, Rossetti, Millais and Ford Madox Brown (not a formal member of the Brotherhood, but very closely associated with its aims) all tackled the subject. They could not be termed feminists, but they, like George Eliot, saw that society had a reticulated aspect, with large knots for the various groups and factions and smaller knots for individ-uals. Society pressed its claims on even the most independent of indi-viduals, and women were among the most dependent. 'There is no creature', declared George Eliot, at the end of *Middlemarch*, 'whose inward being is so strong that it is not greatly determined by what lies outside it.' The fallen woman was at the centre of the social knot, hemmed in by opinion and doughty moral attitudes. The Pre-Raphaelites raised her to the status of an anti-heroine. It is less easy for us today to see why the fallen woman was quite the iniquity that it was in the nineteenth century because we do not understand respectability in the way that the Victorians did. Today the word raises compassion-

ate smiles. In the mid-nineteenth century, respectability was the chief virtue of competitive individualism. It was the standard by which one could crawl from the mass and better oneself. And not just oneself, but one's family. The Victorian adulation of the family is well known, but it was not simply a matter of paternalistic pride. In bettering his family, a man was performing the secular task of bettering the race. Darwin had already shown that evolution was a process of upward mobility, towards increasingly sophisticated models of each species. Social progress, therefore, made possible through respectability, is a mirror of evolutionary progress. As Pitt-Rivers remarked to a meeting of archaeologists, soon after the publication of Darwin's *Descent of Man*, 'the thought of our humble origin may be an incentive to industry and respectability.'

Ford Madox Brown takes the issue of respectability and responsibility in '*Take Your Son, Sir!*' (Plate 23) and places it unequivocally before us. The wronged woman courageously exhibits her baby from the folds of her womb-like clothing to the seducer. He is framed in the round, halo-forming mirror behind her, an ironic reminder of an earlier nuptial painting, Van Eyck's *Marriage of the Arnolfini* (acquired by the National Gallery, London in 1848), where a circular mirror in the background similarly reflects the worldly concerns of the wedded pair. Brown painted this work in 1857, the year of the Matrimonial Causes Act. In 1850, a Royal Commission on Divorce had been set up to enquire into the state of law which denied matrimonial relief to all but the wealthiest. At this time, the legal effect of marriage on rights of property and maintenance was to place in the possession of the husband the ownership of all of his wife's property. He may have uttered the words 'With all my worldly goods I thee endow' at the marriage ceremony, but in essence the worldly goods were all his, and remained so, no matter what form of separation the marriage might subsequently take. The years following the establishment of the commission were noisy ones on this issue, with letters in *The Times* to the Queen from Lady Caroline Norton, and rowdy lobbying in Parliament. The result of the commission, in 1857, was to secularize and democratize the administration of divorce and legal separation. Previously it had been handled exclusively through private acts of Parliament and the ecclesiastical courts. In 1857 it became the subject of ordinary legal process. This may have seemed a small victory, but it aired an issue much in need of attention, and incidentally supplied an artist like Brown with a demanding new subject-matter.

Rossetti's political sympathies were less apparent than Brown's. He began *Found* (see Fig. 5) in 1853 and worked at it intermittently for thirty years. It was unfinished at his death in 1882. Partly the naturalism defeated him (it was the only subject of modern life that he attempted), partly the orthodoxy of the view society would have expected him to take on such an issue, but which was obviously not dear to his heart. The subject is the meeting of a country drover with his former sweetheart, now, alas, become a common prostitute. It is early morning, and the drover is about to cross Blackfriars Bridge on his way into the London markets. Many are the tokens of downfall. The crushed rose lying at the mouth of the sewer-grate; the milky calf enmeshed in a net and standing on the cart that will take it to the meat market; the black cat just waiting on the pavement edge; the brick wall of the churchyard where the fallen woman leans, and 'where the wicked cease from trembling and the weary are at rest'. And yet Rossetti is not resolved. Like the broken woman, one suspects, he would have preferred the life of Cross Keys to the sweet air of Buckinghamshire.

Fig. 5
Dante Gabriel
Rossetti (1828-82)
Complete
Compositional Study
for 'Found'
c.1855. Pen and ink on
paper, 23.5 x 21.9 cm. City
Art Gallery, Birmingham

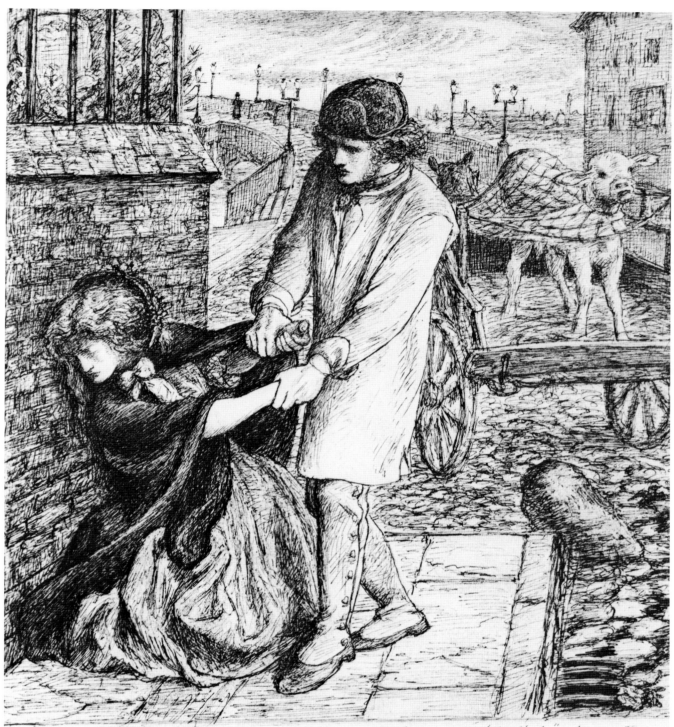

"I remember Thee; the kindness of thy youth, the love of thy betrothal." Jerem. II. 2.

Found

Cross Keys slum, just behind Chelsea, was where Annie Miller (Fig. 23), the model for Hunt's *The Awakening Conscience* (Plate 15), had her origins. Hunt treats the theme of prostitution with no equivocation at all. The St John's Wood love-nest is a den of sin. An absolute equation is made between moral truth and material fact. All the 'fatal newness' of the furniture, as Ruskin called it, calls out the vulgarity of the scene. Casual love equals casual life. And Hunt was not a casual man. Relentlessly, down to the last Turkish knot in the patterned carpet, he pursues his theme of moral regeneration, of 'how the still small voice speaks to a human soul in the turmoil of life'. It was perhaps another of those ambiguities that Annie Miller, if not a fallen woman, then at least one who never rose very far, should have attracted Hunt to such a degree that he wished to marry her (subject to her 'improvement'). Even while Hunt's morality may have been conventional, his choice of Annie as a model was original. The sort of woman that had previously dominated art had been the Keepsake Beauty. During the early Victorian period, her image was circulated in folio volumes known as The Keepsakes, or Books of Beauty, roughly equivalent to today's women's magazines. They dwelt obsessively on feminine beauty, promoting a Barbara Cartland ideal. Dainty-featured, marabou-trimmed figurines breathe virginity from their pages, with just a hint of melting romance and stolen kisses. Thackeray parodied the type in his portrait of Rosie Mackenzie in *The Newcomes*, published in 1854, a year after Hunt's painting of *The Awakening Conscience:*

> Pretty little pink faced Rosie, in a sweet little morning cap and ribbons, her pretty little fingers twinkling with a score of rings, simpering before her silver tea urn which reflected her pretty little pink baby face.

No one confronted with Annie Miller (Fig. 23), or with Fanny Cornforth (Fig. 27), Rossetti's model for *Found* (and his sometime mistress), is going to confuse her with the sort that simpers before tea urns.

Hunt described Millais' pen and ink drawing, *Retribution* (Fig. 6), as an illustration of the 'unconsecrated passion in modern life'. Millais had first-hand experience of unconsecrated passion. He fell in love with Ruskin's wife, Effie, while on holiday with the Ruskins in the Trossachs in the summer of 1853. One result was the annulment of Ruskin's marriage and Effie's subsequent marriage to Millais on 3 July 1855. Another was the series of drawings Millais produced during that interim period, all largely to do with love, disgrace and respectability. *Retribution* is arguably the finest of these. Taut, full of sentiment, and dramatic, it offers a clear example of how the Victorians looked at pictures. Every item augments the tale. The gentleman has been shown into the drawing-room of his mistress. The maid has gone out and closed the door. The man has taken off his top hat and gloves and given the posies he has brought to his mistress. They are still in their ruched paper wrappings, although one bouquet has dropped portentously to the floor, and its fresh flowers spilled onto the carpet. The woman on the sofa is clearly a mistress: she wears no rings on her fingers. The pictures in her room are frivolous. The one directly to her right is of that cricket of a creature — a ballerina. To make the analogy more pointed, literally, the bottom edge of the mount, on which the dancer poises her toe, is seen not to be a straight edge after all, but an arrow, its shaft directed towards the young unmarried woman. Unbeknown to the gentleman, his wife and two children have followed him to his bower of bliss. The maid has barely had time to spin round before she revolves again, this time to show the young wife in, and to

wait and see what happens. The mistress is clearly horrified. She did not know the gentleman had responsibilities. She fingers the young wife's wedding ring. The young daughter points a pump downward towards the cross on the carpet. Respectability has been unmasked, and found to wear a faint heart beneath.

Looking at pictures in this way was not special to the Pre-Raphaelites; indeed, it was the way the Victorians in general expected to read works of art. Until Whistler came along with his tones and his moods, painting was a concrete visual language, where every mark was a fact, and every fact an article of faith. One area, however, in which the Pre-Raphaelites did make this their unique province was landscape painting.

Two features of early Italian art that specially impressed the Pre-Raphaelites were its brightness of colour and its minuteness of detail. The clear, bright colour was achieved with the minimum of shading. Many of the examples of early Italian art known to the Pre-Raphaelites were frescoes, which employ a technique peculiar to the medium. It demands the use of an undercoat of wet white plaster onto which the colours are quickly glazed. The two then dry together, ensuring permanence and brilliance. Such vividness of colour was deliciously refreshing to artists brought up to revere the bituminous gloom of Pickersgill and Etty. Much of the reverence for sombre canvases, however, was the result of a misguided conceit that the masters had painted in tarry browns and black. In fact, many of the old canvases were simply badly discoloured. The old varnishes, made of natural pig-

Fig. 6
John Everett Millais
(1829-96)
Retribution
1854. Pen and ink on
paper, 20.3 x 26.4 cm.
Maas Gallery, London

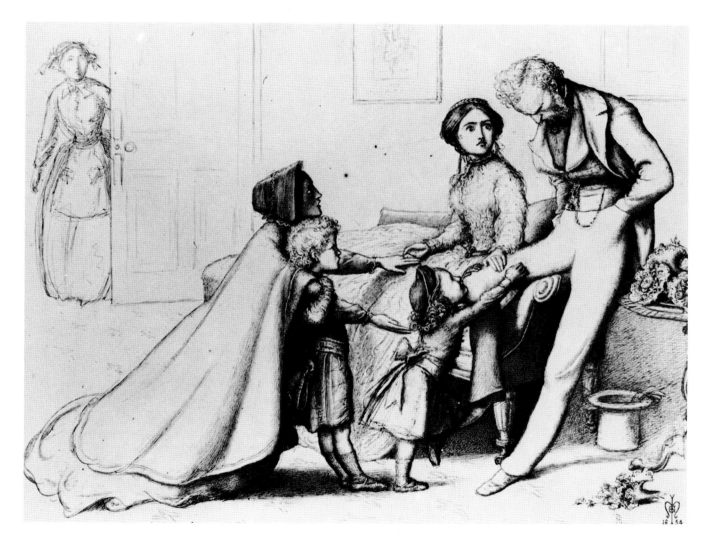

ments, yellowed and gave to their images the dubious charm of an overall nicotine glow. Two artists whose visits to Italy during the 1840s resulted in considerably lightened palettes were Ford Madox Brown and William Dyce. Brown became intimately connected with the Brotherhood; Dyce was an enthusiastic supporter and an inspiration to the younger artists. It was while he was in Italy during the winter of 1845-6 that he kept careful notes on his observations of Italian art. He was particularly in awe of Pinturicchio's work, in which, he claimed, 'mere brillancy and harmony of effect exceed any other production I am acquainted with'. He determined to get to the bottom of this technique, and came to conclusions which gave the Pre-Raphaelites their cue:

> I suspect that we modern painters do not study nature enough in the open air, or in broad daylight, or we should be better able to understand how the old painters obtained truth by such apparently anomalous means. In sunlight, shadows partake largely of the local colour of the objects, and still more so in the shade, viz: seen by the diffused light of the sky; indeed in the open air I have observed that peculiar indefiniteness of the shadows and darkening of the receding and undercut parts which is so characteristic of the older painters, and which nobody doubts is more effective for mural painting on a large scale than the sort of painter's studio shadowing, which from habit and prejudice one can hardly nowadays avoid. The Germans such as Cornelius attempt to follow the old painters in their method of darkening rather than shadowing: but without success simply because they learn the method from old art rather than from nature ... Of this I am quite convinced that no degree of study in the painting room with a small confined light will ever enable one to make any approach to the kind of open daylight reality obtained by the early painters.

One of the first Pre-Raphaelite landscapes to be exhibited was not by a founding member of the Brotherhood, but by Charles Allston Collins, one of Millais' closest friends. This was *May, in the Regent's Park* (Fig. 7), shown at the Royal Academy in 1852. Collins lived in Hanover Terrace, overlooking the park, and the picture was painted from the window of a neighbour's house. It is an extraordinary achievement. Nothing is generalized. One reviewer even suggested that it had been painted with an eyeglass. Certainly every single detail has been picked out with scintillating precision. The background trees do not coalesce into a wavy clump as in fact the eye would naturally see them at a distance. Every branch is a separate spear. The painstakingly worked details have the clarity of crystal droplets, so that the whole picture comes together like a glass chandelier, quivering, gleaming, tinkling almost. The reviewer for the *Athenaeum* objected to the picture precisely because the eye does not see in this way:

> The botanical predominates altogether over the artistical, — and to a vicious and mistaken extreme. In nature there is air as well as earth, — she masses and generalizes where these facsimile makers split hairs and particularize. They take a branch, a flower, a blade of grass, place it close before them and as closely copy it, — forgetting that these objects, at the distance imagined in the picture, could by no means be seen with such *hortus siccus* minuteness.

But this critic had probably not been reading Ruskin. If he had done, he had not taken in its singular message. Although Ruskin did not see a Pre-Raphaelite canvas until 1850 (when he was forcibly taken by

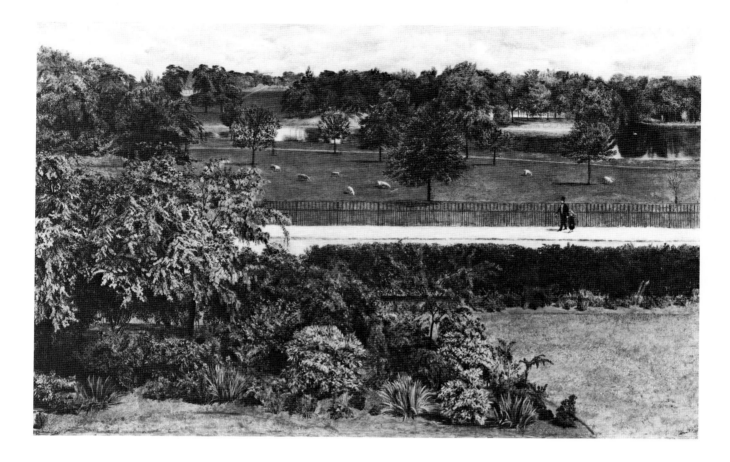

Fig. 7
Charles Allston
Collins (1828-73)
May, in the Regent's
Park
1851. Oil on canvas,
44.4 x 69.5 cm.
Tate Gallery, London

Dyce to the Royal Academy to look at Millais' *Christ in the House of his Parents*; Plate 6), his first two published volumes of *Modern Painters* (1843 and 1846) exerted an enormous influence on the Pre-Raphaelites. The book was primarily a defence of that hoary axiom Truth to Nature. But the way Ruskin sought its end was wholly novel. Ruskin argued for particularity, for individuality as opposed to broad allusions, for local truths rather than general perceptions. This led directly to an argument for finish and detail. He spurned quickness of execution and sketchiness. Certainly a picture must have unity, he argued, but not at the expense of 'the inexhaustible perfection of nature's details'. As a practical flourish, he exhorted the artist to ask himself, when he thought he had finished his painting, 'Can my details be added to? Is there a single space in the picture where I can crowd another thought?'

'By Jove,' exclaimed Holman Hunt, on reading *Modern Painters*, 'passages in it made my heart thrill. He feels the power and responsibility of art more than any author I have ever read.' In Hunt's early Pre-Raphaelite paintings, *The Hireling Shepherd* (Fig. 20), *Our English Coasts* (Plate 13), *Valentine Rescuing Sylvia from Proteus* (Plate 9), one can feel his heart thrilling to the natural world he painted with such intensity. He painted the landscape parts of these works out-of-doors, introducing to his views a prismatic palette, and producing thereby some of the most innovative painting of the century. The French critic Robert de la Sizeranne, writing at the end of the century, claimed that Hunt was the forefather of all modern painting, and called on *Our English Coasts* as his chief witness to this fact:

The blood-red sheep in indigo bushes, on rocks chiselled like sugar-candy, under an audacious sky, recall the worst excesses of our 'luminists'; and, remembering that this picture dates forty-one

years back, it is a question whether it is not one of the earliest manifestations of the open-air school, and whether the violet horses of M. Besnard are not the descendants, by a strange pedigree, of the red sheep of Mr Hunt. With all his extravagances Hunt made a colour speak which before him had slumbered heavily. Sometimes it is only a flash, but by this flash it may be seen how right the P.R.B. were to desert the studio for the fields, and a misunderstood tradition for nature.

The trouble is that Hunt stuck to the narrowest interpretation of Truth to Nature throughout his long career. As he aged, this adherence to discipline made him into something of a martinet, punishing the forms that he painted instead of finding pleasure in them. Later works such as *The Shadow of Death* (1870) and *The Triumph of the Innocents* (1887) bear the stamp of this cynicism and they betray Hunt's dogged determination to stick to his guns, no matter whether or not the guns were pointing in a direction different from that of his youth. For as the years passed the differences in personality between the three principals of the group began to reflect the artificial unity of the Brotherhood. By 1853 the formal association of the Brotherhood had collapsed and Hunt, Millais and Rossetti went their separate ways, each with his following. Those who followed Hunt, such as John Brett, William Davis, John Inchbold and George Price Boyce, continued in the vein of scientific naturalism. Boyce's watercolour of *The Mill on the Thames at Mapledurham* (Fig. 8) shows the felicities of this intense concentration on natural detail. Though the bright red roofs and the emerald green grasses are strongly contrasted, the image is keen not harsh, curious not insensitive. Davis on the other hand, and Brett even more so in his late sea-pieces, exhibit the dangers of this technique. Their scrutiny becomes blank; they work like vivisectionists, and betray science for scientism, material for materialism. In their photographic renditions of landscape they try to prove that an exact rendering of fact produces an exact knowledge of reality. It was doomed to fail. Their works are so factually complete and correct, they suffocate the imagination. Rossetti however went in the opposite direction. His later pictures are so imaginative, they fail to have much reality. In *The Blessed Damozel* (Plate 44), painted in 1871-7, the sentiment that he controlled so finely in his drawing for *Found* (Fig. 5) and in the beautiful illustrations for the Moxon edition of Tennyson's *Poems* (1857; see Plate 28) has gone slack; as a result the painting is both emotionally and formally flaccid. The tight, sharper surfaces of his early work have relaxed into slow rhythms and veiled forms — a stylistic self-indulgence only paralleled in the forlorn lines from his own poem, *A Superscription*, written in the same year: 'Look in my face, my name is Might-Have-Been; I am also called No-More, Too-Late, Farewell.'

During the 1850s, however, Rossetti made a unique contribution to English painting with a series of lapidary watercolours on themes from Arthurian Legend. In *Sir Galahad at the Ruined Chapel* (Plate 28) opaque watercolour is used with the effulgency of medieval stained glass or cloisonné enamels. It expressively describes the emblazoned and heraldic world of courtly romance. The bright, pure colour and the intimate scale of the watercolour emphasize the physicality of the scene — and yet it is not about events of the physical world at all, but about myth, romance, ether. The abyss that separated romance from reality in the nineteenth-century world is temporarily bridged by Rossetti. Alone among the Pre-Raphaelites he could penetrate imaginatively into the chivalric world of medieval romance and convey it with a remarkable sense of actuality.

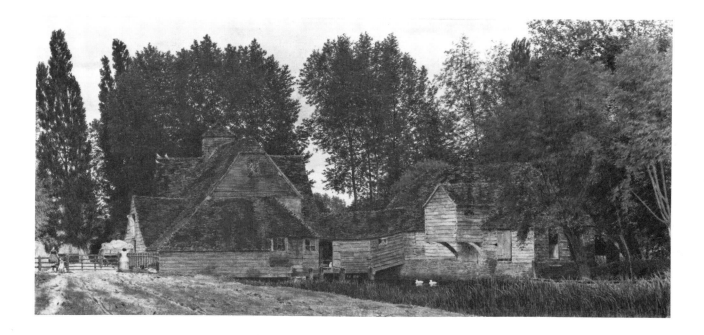

Fig. 8
George Price Boyce
(1826-97)
The Mill on
the Thames at
Mapledurham
1860. Watercolour on
paper, 26.7 x 55.9 cm.
Fitzwilliam Museum,
Cambridge

Millais, after 1853, went the way of the world. In 1853 he was elected an Associate of the Royal Academy, the very institution which the Brotherhood had so reviled. Ten years later he became a full Academician. His paintings, during this ten-year period, became gradually less gauche, less controversial and less interesting. His farewell to the ideals of the Brotherhood was made in 1856, with two of his most lyrical paintings, *The Blind Girl* and *Autumn Leaves*. Both these works are touching, although they hover on the brink of obviousness and mawkishness over which Millais soon plunged with confidence as well as with financial acuity. Nonetheless, both these works display Millais' power to use colour and detail elegiacally, and in compositions of Tennysonian brilliance. At their best both these artists, Millais and Tennyson, shared a certainty of touch and an economy of means that make their images flash, and their observations pass into art with the immediacy of inspiration. Tennyson, like Millais in his Pre-Raphaelite phase, rewarded his public with an attention to natural detail that was almost biological. It was what the middle-class public demanded. They themselves, only half a century ago, had belonged to the countryside and, in their urban world of exile, they wanted reminders of that imaginary demi-paradise. In faultless images Tennyson provided them:

> Long lines of cliff breaking have left a chasm;
> And in the chasm are foam and yellow sands;
> Beyond, red roofs about a narrow wharf
> In cluster; then a moulder'd church; and higher
> A long street climbs to one tall-tower'd mill;
> And high in heaven behind it a gray down
> With Danish barrows; and a hazelwood,
> By autumn nutters haunted, flourishes
> Green in a cuplike hollow of the down.

<div align="right">ENOCH ARDEN</div>

Millais too possessed this mastery of the illusionistic style. But unlike Tennyson, who grew hortatory as he grew in public stature, Millais candied. The osseous structures of his Pre-Raphaelite paintings decomposed into sugary mounds and bore sweet names such as *Cherry Ripe* and *The Little Speedwell's Darling Blue* (taken from a line in

Tennyson's *In Memoriam*, but illustrating not the full poetic apprehension of that poem, but a darling young girl). Controlled by his contact with the Pre-Raphaelite Brotherhood, Millais was able to produce the most delicate records of natural history. Left on his own, he developed the true strain of his soul, which proved to be facile.

The man who understood Pre-Raphaelitism with greater intelligence and greater poetry than any other was not an original member of the Brotherhood at all, but Ford Madox Brown, who had declined to join the group in 1848 on the grounds that he had no faith in coteries. He was, nonetheless, the single most important influence on the movement and the author of its most potent and most brilliant pictures. In 1961, David Hockney painted a slurred version of *The Last of England* (Plate 19). The man and the woman of Brown's painting have become two boys, and all the details of the original are painted out in Hockney's version — the red and white cabbages threaded through the ship's netting (to salt them for the long journey), the young girl sinking her teeth into a Granny Smith, the smoker with his clay pipe, the top-hatted bookie, with a bottle under his arm and a tooth missing from his upper gum. It is paradoxical homage to the literalness that Hockney admired in Brown, where the fascination of how things look, exactly, is touched at every point with the artist's affection. It was the literalness that Brown, in his turn, admired in Hogarth, whom Brown revered as the true founder of English painting. Hogarth's expostulations against the puffed-up claims for foreign artists and against the self-styled connoisseurs of art, who brought to England 'shiploads of dead Christs, Madonnas and Holy Families' might well have been uttered by Brown. Unlike Hogarth, though, Brown trained as a painter almost entirely abroad. He was born in Calais, the son of a half-pay naval officer, and grew up there among its peripatetic community of naval officers and decaying gentlefolk. When he was fourteen his family moved to Bruges and a year later to Ghent. In both cities Brown received instruction from former pupils of Jacques-Louis David — Gregorius and Van Hanselaer respectively. In 1837 the promising student moved to Antwerp to study under Gustave Wappers (later created a baron in recognition of his services to Belgian painting) and produced some unexceptionable history paintings with such titles as *A Fleming watches the Duke of Alba go by* and *Elizabeth at the Deathbed of the Countess of Nottingham*. What moved him towards making pictures of modern life, framed by moral and dramatic narrative, was an innate dislike of academicism, slumbering for the most part in Belgium, but awakened when he visited Paris in 1840. He entertained thoughts of settling there and looked around the ateliers in search of a congenial niche for himself. What he discovered was that 'cold pedantic drawing and heavy opaque colour are impartially dispensed to all in those huge manufactories of artists', and he turned, dismayed, in search of subjects where his gift for spry, incidental observation could be used to the full. He found the subject under his very nose, in the life all around him. His suspicions that art, like life, must have its basis in personal experience, were confirmed in England, where he settled in 1844. Surrounded by acquaintances such as Cruikshank, Tenniel and John Martin, he discarded the classical concepts of beauty and the elegant refinements of style that had been the staple of Wappers' teaching and determined, at a moment just before the formation of the Pre-Raphaelite Brotherhood, that visual truth alone must be the stuff of painting. Like Delacroix, one of the very few painters whose work Brown had admired in Paris, he was convinced that 'the beautiful is everywhere ... and each man not only sees it, but must render it in his own way'. So when he came to paint *The Last of England* in 1852, his

ideas sustained by the Pre-Raphaelite Brotherhood, he painted a portrait of himself and his wife sitting on board ship, wearing their everyday clothes, with their knuckles and finger-joints going livid, as they face the cold of a drizzling October day, on the open sea, a mile off the coast at Gravesend. Hogarth, a century earlier, had painted his self-portrait with his dog seated lovingly before him, a strop against which the art establishment (who probably expected to see the Muse of Art instead of a pug) might sharpen their ideas. Samuel Johnson lauded this practice. 'I had rather see the portrait of a dog I know than all the allegories you can show me', he proclaimed, and indeed nothing dates quicker than timeless allegory. Brown's painting, about work and justice, about the disorder of contemporary society, about emigration and homeland and future, is more immediate today with all its period details, than any of the allegories painted by the Victorian Olympians of the same period. Watts' *Love and Death*, Crane's *The Roll of Fate*, Poynter's *Psyche in the Temple of Love* smack far more insistently of the world of Mr Podsnap and Mr Gradgrind than Mr and Mrs Brown, implacable in their winter weatheralls, in the bows of *The Windsor*.

Ford Madox Brown's masterpiece, however, and one of the great English paintings of the nineteenth century, is *Work* (Plate 41). Here all the components of Pre-Raphaelitism come together: the brightness of colour, the minuteness of detail, the subject from contemporary society, and the heroism of modern life. Enormously complex in its very particularity and in its inability to focus clearly the different perspectives of the problem, *Work* is a true pictorial amalgam of the great issues of the age: the relations between democracy and freedom, liberty and justice, labour and profit, within an industrial context. To the right of the picture stand the intellectuals, Thomas Carlyle and Frederick Denison Maurice. Their work is the organization of the society from which they stand just a little aloof. Maurice was the leader of the Christian Socialist Movement and founder of the Euston Road Boys' Home, for which there is a poster on the brick wall on the left of the painting. When Edward Burne-Jones married Georgiana Macdonald in 1860, the boys at Euston Road made most of the marriage furniture for their part-furnished rooms in Russell Place: an oak table, highbacked, black-stained chairs with rush seats, and a panelled wood sofa (also stained black) from designs by Philip Webb. Standing with Maurice is Carlyle, whose fulminations against capitalism profoundly influenced Brown's thinking. It was Carlyle's belief in the sacred value of work that prompted and underscored this painting. 'All work, even cotton-spinning, is noble', said the Sage in *Past and Present* (1843) and in the same book went on to add:

> A man perfects himself by working. Foul jungles are cleared away, fair seed-fields rise instead, and stately cities; and withal the man himself first ceases to be a jungle, and foul unwholesome desert thereby ... The man is now a man.

All those who work, whether they be navvies shovelling dirt, beersellers crying their wares, wretched flower-sellers plying their bunches of whitewort and grasses, or trimly dressed ladies of the middle classes dispersing religious tracts, share terrain with the intellectuals. Only those who don't work, the couple on horseback, he in his shiny top hat, she with gloved hands, are on a different level from those who work and those who wish to work. These are the idle rich. All progress between them and the workers is blocked by the barriers of wealth and privilege. The electioneers with their sandwich boards strut up and down Heath Street: an orange-seller is jostled by a policeman for having committed the crime of resting her basket on a post:

'money! money! money!' has been scribbled as part of the graffiti on the wall. The painting bulges with incident. It is a veritable history of contemporary life. But, ironically, while it successfully develops the iconography of the working man, there is nothing to suggest that even then the machine was poised to take over the working man's strength, and thus injure his dignity and diminish his worth.

No one felt more keenly the threat of the machine than William Morris. Carlyle was disgusted by the way in which capitalism reduced every human value to a cash value, but he was not concerned with art. He counselled labour as a religious sacrament, but he did not understand the implications or the importance of creative satisfaction within labour. That inspired task was left to Morris. Morris was an undergraduate at Oxford when he first encountered Pre-Raphaelitism. He and his closest friend at Exeter College, Edward Burne-Jones (Fig. 9), were intended for the Church, but they were dazzled by the Froissartian sparkle of the 1840s and 1850s. They read Charlotte Yonge's *The Heir of Redclyffe*, Ruskin's *Stones of Venice* and Carlyle's *Past and Present*, and decided that art and literature — particularly medieval art and literature — were more interesting to them than a future as clergymen. They also read *The Germ*, the literary magazine of the Pre-Raphaelite Brotherhood, which came out in four numbers between January and April 1850, and decided to establish themselves as a Brotherhood too, to wage a 'Crusade and Holy Warfare against the Age'. How they were going to wage this war was not settled until 1856, when the weaponry was supplied by Rossetti, by this time a rather weary campaigner in the field of art reform. Burne-Jones went to London in January 1856 to meet Rossetti. He found him at the Working Men's College in Great Ormond Street (founded by Frederick Denison Maurice in 1854 to provide adult education in the liberal disciplines), where he was giving an art class, and fell immediately under his spell. He left Oxford without taking his degree and became Rossetti's disciple. Morris took a little longer to fall. After taking his degree, he became apprenticed to the Oxford architect, G.E. Street, whose interest in things medieval matched Morris' own. In fact, Street's address to the anniversary meeting of the Ecclesiological Society in 1858 defended medievalism and Pre-Raphaelitism against the claims of pastiche and historicism in terms that Morris must have applauded:

> We are medievalists and rejoice in the name: to us it implies a joy in all that is best, purest, truest, in our art, and we deny altogether that it rightfully implies any disposition to refuse to this age what history really entitles it to demand. We are medievalists in the sense of wishing to do our work in the same simple but strong spirit which made the man of the 13th century so noble a creature, in the same sense exactly it appears to me as the Pre-Raphaelites have taken their name, not because they wish for an instant to copy what other men have done — no one has charged them with this — but because they, as we, see in the name a pledge of resistance to false and modern systems of thoughts and practice in art.

Architectural practice did not prove as stimulating to Morris as architectural prose. He left Street's office within the year, bored by the exercise of having to copy a detailed drawing of St Augustine's Church in Canterbury that Street had set him, and followed Burne-Jones to London. Now Morris soaked up the Rossettian miasma. 'I want to imitate Gabriel as much as I can', he said, at the moment when Rossetti's inspiration was at its most medieval. But the draw towards medievalism was not the same for Rossetti as it was for Morris. Rossetti saw himself as a latter-day Sir Galahad, permanently in search of the

Fig. 9
Photograph of William Morris and Edward Burne-Jones in the Garden of Burne-Jones' Home, The Grange, in North End, Fulham, 1874
Hammersmith Public Libraries

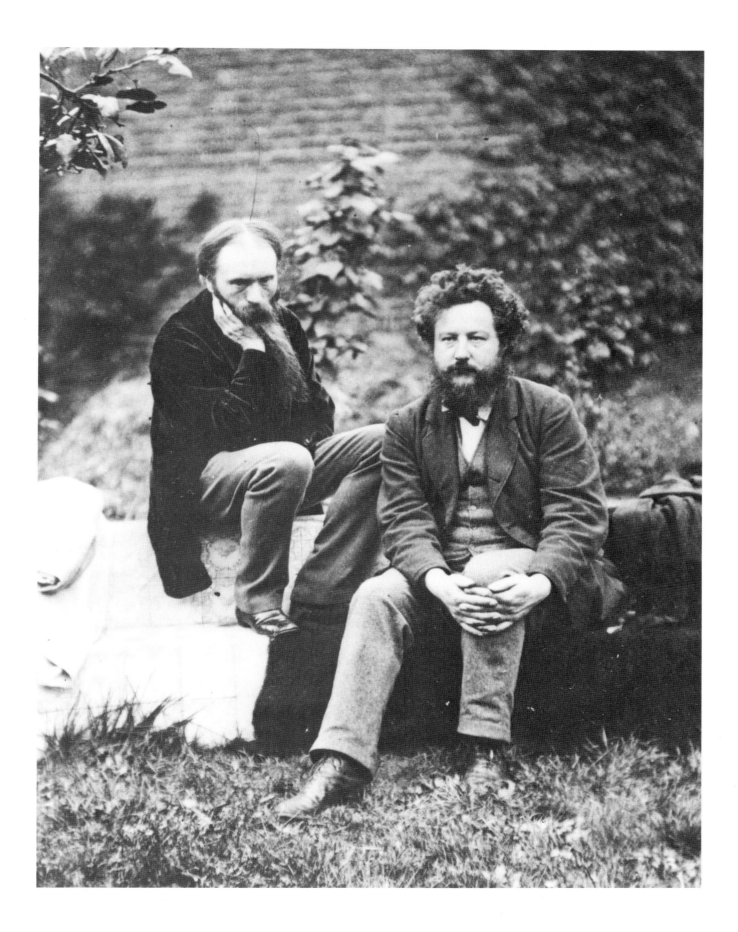

Fig. 10
Photograph of the
Red House, Bexley
Heath
National Monuments
Record, London

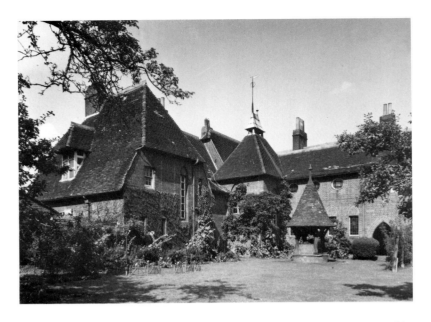

Holy Grail, a knight in the pursuit of Art, whose quest was answered in those flares of insight when the vision became concrete, and he saw 'the spiritual city and all her spires, And gateways in a glory like one pearl'. Morris was pragmatic. He did not dream of the Silver Chalice as a symbol. He wanted to design it, to hammer its metal edges, and to chase it. Morris had a natural tool-sense. It made him loathe 'all those accurate mouldings and perfect polishings, and unerring adjustments of the seasoned wood and tempered steel' of Ruskin's description, which were, to Morris, symptomatic of the inhumanity of the age. The point about medievalism, as far as Morris was concerned, was its humanity. In this he concurred fully with Ruskin:

> Observe, you are put to a stern choice in this matter. You must either make a tool of the creature, or a man of him. You cannot make both. Men were not intended to work with the accuracy of tools, to be precise and perfect in all their actions. If you will have that precision out of them, and make their fingers measure degrees like cog-wheels, and their arms strike curves like compasses, you must inhumanize them. All the energy of their spirits must be given to make cogs and compasses of themselves ... On the other hand, if you will make a man of the working creature, you cannot make a tool. Let him but begin to imagine, to think, to try to do anything worth doing; and the engine-turned precision is lost at once. Out come all his roughness, all his dullness, all his incapability; shame upon shame, failure upon failure: but out comes the whole majesty of him also ...

Morris soon discovered that his aptitudes lay in the decorative arts rather than in the purer realms of painting and sculpture. Rossetti may dream of a Palace of Art, but Morris must furnish it. When Morris married Jane Burden in 1859 and came to furnish their home, the Red House at Bexley Heath (Fig. 10), designed by Philip Webb, he looked around him at the typical products of the period and found them vicious. Such products, he believed, vitiated the people who had to live with them, and he decided to start his own firm of artist-craftsmen, who would manufacture work that would be essentially simple, of good materials and sound workmanship. Both Jane and May Morris were active in Morris' firm. Jane executed many of Morris' embroidery designs. May (Fig. 11), born in 1862 and trained in several crafts by her father, became head of The Firm's embroidery department in 1885.

One of the early associates of The Firm, as Morris' decorating company became known, was Walter Crane. He went to the Great Exhibition in 1851, at the time vaunted as the acme of artistry, and came away with the same impression of English taste as Morris:

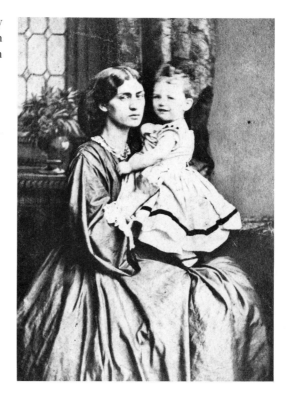

> The last stages of decomposition had been reached, and a period of, perhaps, unexampled hideousness in furniture, dress and decoration set in which lasted the life of the second empire, and fitly perished with it. Relics of the period I believe are still to be discovered in the cold shade of remote drawing-rooms, and 'apartments to let', which take the form of big looking-glasses, and machine-lace curtains, and where the furniture is afflicted with curvature of the spine, and dreary lumps of bronze and ormolu repose on marble slabs at every opportunity, where monstrosities of every kind are encouraged under glass shades, while every species of design-debauchery is indulged in upon carpets, curtains, chintzes and wallpapers, and where the antimacassar is made to cover a multitude of sins. When such ideas of decoration prevailed, having their origin or prototypes in the vapid splendours of imperial saloons, and had to be reduced to the scale of the ordinary citizen's home and pocket, the thing became absurd as well as hideous. Besides, the cheap curly legs of the uneasy chairs and couches came off, and the stuffed seats, with a specious show of padded comfort, were delusions or snares.

Fig. 11
Photograph of Jane Morris Holding her Daughter, May Morris, c.1865.
William Morris Gallery, Walthamstow, London

Morris' desire to sweep clean the parlours of their machine-stitched antimacassars, their pictures of parrots done in Berlin wool-work and their bead mats, became axiomatic. The 'Morris' chair (designed, in fact, by Philip Webb) is still in production (Fig. 12). Its ebonized beechwood frame, with rush seating, turned legs and straight back, was based on a traditional Sussex chair and today its clean looks have become something of a basic commodity in Habitat-orientated homes. This is the problem with Morris. His designs, while they cleared away much of the confusion regarding the proper use of materials and the functional purpose of objects, led to a somewhat uniform concern with 'pure' taste. Unlike Rossetti's home in Cheyne Walk, filled with bric-à-brac scavenged from the junk shops of Hammersmith and Lambeth — Coromandel screens, Venetian mirrors and chandeliers, Chinese bronze storks, heavy curtains of Utrecht velvet — Morris' homes at Kelmscott Manor in Oxfordshire and at Kelmscott House, Hammersmith, were the progenitors of a taste as standardized as the machine-made artefacts he so despised: a taste expressed in Morris wallpapers, Morris chintz upholstery, and, on the floor, Morris-inspired rush-matting. The 'Morris taste' is not an expression of personality; it is the expression of an ideal. And like most ideals, however worthy, it tends to be rather humourless.

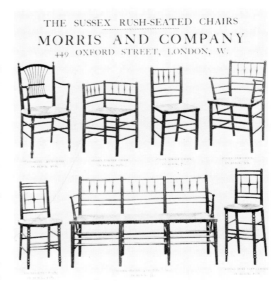

Fig. 12
The 'Sussex' Rush-Seated Chairs
Page from a catalogue of Morris and Co., c.1910.

Rossetti reserved his wit for his house. Burne-Jones reserved his for his private notebooks and letters. It never penetrated his exhibited work. Ideals of beauty and ideals of comedy were segregated as far as Rossetti and his fellow Victorians were concerned. Whole areas were boarded up against the intrusion of levity: colour could not be seen at a funeral, a joke could not be made in poetry, poking fun could not be done in paint. It was another angle of respectability that laughter should not peal in the pantheon of Art. Looking at the solemnity of so much of Burne-Jones' publicly exhibited work and at the frisky humour of the cartoons he produced for his friends and family, the separation of Art from Humour becomes obvious (Fig. 13). Melancholy stares from the faces of the beautiful, ornamental women of

Fig. 13
Edward Burne-Jones
(1833-93)
Caricature of William
Morris on a Pedestal,
as an Orator
Pencil on paper,
12.4 x 7.6 cm. City Art
Gallery, Birmingham

Strudwick's *The Gentle Music of a Byegone Day* (Plate 47), as they play their musical instruments with such wan expressions, such listless grace; but melancholy, as Mark Rutherford pointed out in his autobiography, *Deliverance*, is easy. It is wit that is hard, wit that gives philosophy its edge and morals their generosity. And it is here that the Victorian intelligence, and late Pre-Raphaelitism in particular, is at its softest. Burne-Jones, and those like him who were heavily influenced by the superficialities of Rossetti's style — Evelyn de Morgan, Frederick Sandys, Spencer Stanhope, John Melhuish Strudwick — became partners in elegant lassitude. The somnolent dreamers and swooners that they produced and perpetuated have become generally identified with a 'Pre-Raphaelite type'. But these were the offshoot of the main trunk of Pre-Raphaelitism, growing in attenuated form for lack of light and solid nourishment. What this shoot fed on was the insubstantial hope of the late Victorian period that somewhere, beneath the blanket of materialism that was threatening to stifle every human value, lay a better world. In the age of the gunboat and the deep-sea cable, the glimpse of another world — a world where exotically arrayed figures wander slowly through comely rooms — could be a solace and a comfort. It may be only a decorative shadow of real life, but the pretence was more pleasant than the reality of smoke-filled Birmingham, Manchester, or Glasgow. The works of Evelyn de Morgan and Strudwick are often arresting. They could be considered on the same lines as Morris' 'Sussex' chair: of good materials, sound workmanship, and, in the paintings, with the rich, suggestive surface decoration Morris recommended for his cabinets and wall coverings. But they never transcend the merely decorative. Without great adjustment to the harmony of a room, a painting by Evelyn de Morgan could be replaced by a piece of pottery by her husband: a handpainted earthenware tile, or a lustrously glazed 'majolica' plate (Fig. 38). The effect would be similar because effect is what these paintings are about. They are a matter of manners before morals.

In 1897 Victoria celebrated her Diamond Jubilee. Rossetti, Brown, Millais and Morris were all dead. Morris' anxieties about the hideousness of the age were confirmed in the commemoration mugs and other examples of Jubilee souvenir ware. Even so unsubtle a critic as Ouida, living the life of a recluse in Lucca, wrote to the editor of the *Humanitarian Review* to condemn the event as the 'apotheosis of Philistia'. With typical exuberance, but with accuracy, she wrote in the late 1890s that 'the chief creation of modern life is the Cad; he is of exclusively modern manufacture ... the entire epitome, the complex blossom and fruit in one, of what we are told is an age of culture.' The Cad was the summation of all Ruskin's fears about what would happen when society lost its 'unity of feeling'. Morals, manners and money were broken down into isolated areas of activity, and men were tagged accordingly: Cads, Aesthetes or Trade. The unitary quality of life, which to a certain extent still existed until the mid-nineteenth century, splintered irrevocably in the latter half of Victoria's reign. One had to be a professional to know what was going on in the arts or the sciences. Both the porter and the President of the Royal Academy could get the point of Wilkie's *Grace Before Meat*, whatever one might think of it as a painting. But could the same be said of Rossetti's *Beata Beatrix* (Plate 39) or of Burne-Jones' *Laus Veneris*? No. They breathe a purer air. They are wilfully directed towards those who have a little training in the higher sensibilities. One begins to need to know the jargon to get the real point of these paintings, just as surely as one needs to know the jargon to understand anything of the social sciences, or computer technology, or even literary criticism these days. And in the arts today, in

minimalism for example, one can see plainly where the roots of that dry, specialist knowledge are planted.

In 1899 the Cad went off to the Boer War. Imperialist sentiment billowed up in the 1890s as religious debates died down. It was as if the Empire had taken the place of Religion as the great popular deity. Even the high-priest of the Aesthetes, Oscar Wilde, recognized as much in his poem *Ave Imperatrix*, where he talks about the 'spears of crimson-suited war'. As the handmaiden of the Empire rather than of Religion, Art put off her old, intricate and carefully spun dress and put on a new one of ostentatious smartness. It was not the failure of Art, so much as its capitulation. Pre-Raphaelitism is, after all, the art of the Industrial Revolution. The capabilities of machines looked glamorous to the Brotherhood when they started out. 'We miss the poetry of the things about us,' wrote F.G. Stephens in the fourth issue of *The Germ*:

> ... our railways, factories, mines, roaring cities, steam vessels, and the endless novelties and wonders produced every day; which if they were found only in the Thousand and One Nights, or in any poem classical or romantic, would be gloried over without end; for as the majority of us know not a bit more about them, but merely their names, we keep up the same mystery, the main thing for the surprise of the imagination.

Fired by an enthusiasm for a machinery whose power they did not understand, the Brotherhood, nonetheless, reflected the vigour and punch of industry in their early works, showing what strength it had in their beautiful first paintings, in the impetus it gave to design and to book illustration, and in the production of such masterpieces as *Work*. When they began to know a little better industry's appetite for uniformity, they fled to the safer realms of romance. The graceful youths of Burne-Jones, Strudwick and de Morgan are like the children of self-made men, the prosperous manufacturers who were in fact the major patrons of the Pre-Raphaelites. Embarrassed by their parvenu parents, such children try all the harder to be what they think is 'cultured'. Their parents may look with irritation at their pretension and their silliness, but they can do little to diminish the expectations and the assumptions that their children have come to regard as their right and which the parents themselves have laboured towards. Something, though, of the independent spirit of the *pater familias* lingers still in later generations of artists. The Pre-Raphaelites cannot be said to have founded any great school of painting. Much of their later work is a patent disappointment. But they have left a legacy of thought that encourages artists to work in defiance of smugness and indifference, and often in revolt against popular expectations. The real heirs of Pre-Raphaelitism, though, are not the self-proclaimed avant-garde, their publicists or propagandists. They are the independent artists who simply work steadily on, unruffled by fashion or by 'movements' in art; the artists who go, as Ruskin advised, 'to Nature in all singleness of heart, and walk with her laboriously and trustingly'. As long as such artists persist, Pre-Raphaelitism can still be said to draw breath.

Select Bibliography

Helen Rossetti Angeli, *Dante Gabriel Rossetti: His Friends and Enemies*, London, 1949

Helen Rossetti Angeli, *Pre-Raphaelite Twilight: The Story of Charles Augustus Howell*, London, 1954

Mary Bennett, *Ford Madox Brown: 1821-1893* (catalogue of an exhibition organized by the Walker Art Gallery, Liverpool), 1964

Mary Bennett, *PRB: Millais: PRA* (catalogue of an exhibition organized by the Walker Art Gallery, Liverpool), 1967

Mary Bennett, *William Holman Hunt* (catalogue of an exhibition organized by the Walker Art Gallery, Liverpool), 1969

Ian Bradley, *William Morris and his World*, London, 1975

Georgiana Burne-Jones, *Memorials of Edward Burne-Jones*, London, 1904

John Gordon Christian, *Burne-Jones* (catalogue of an exhibition organized by the Arts Council of Great Britain), 1975

Kenneth Clark, *The Gothic Revival*, London, 1928

Walter Crane, *An Artist's Reminiscences*, London, 1907

Oswald Doughty, *A Victorian Romantic: Dante Gabriel Rossetti*, London, 1949

Henry Treffry Dunn, *Recollections of Dante Gabriel Rossetti and his Circle*, London, 1904

Joan Evans (ed.), *The Lamp of Beauty: Writings on Art by John Ruskin*, Oxford, 1959

Penelope Fitzgerald, *Edward Burne-Jones: A Biography*, London, 1975

William Fredeman, *Pre-Raphaelitism: A Bibliocritical Study*, Cambridge, Mass., 1965

William Gaunt, *The Pre-Raphaelite Tragedy*, London, 1942

William Gaunt and M.D.E. Clayton-Stamm, *William de Morgan*, London, 1971

John Gloag, *Victorian Taste*, London, 1962

Rosalie Glynn Grylls, *Portrait of Rossetti*, London, 1964

Philip Henderson, *William Morris: His Life, Work, and Friends*, London, 1967

Timothy Hilton, *The Pre-Raphaelites*, London, 1970

Ford Madox Hueffer, *Ford Madox Brown: A Record of his Life and Work*, London, 1896

William Holman Hunt, *Pre-Raphaelitism and the Pre-Raphaelite Brotherhood*, London, 1905-6

Robin Ironside, *Pre-Raphaelite Painters* (with a descriptive catalogue by John Gere), London, 1948

W.R. Lethaby, *Philip Webb and his Work*, London, 1979

Mary Lutyens, *Millais and the Ruskins*, London, 1967

Jeremy Maas, *Victorian Painters*, London, 1969

John Guille Millais, *The Life and Letters of Sir J.E. Millais*, London, 1899

John Nicoll, *The Pre-Raphaelites*, London, 1970

Valentine Prinsep, 'Reminiscences', *The Magazine of Art*, vol. XXIV, 1904

W.G. Robertson (ed.), *Burne-Jones' Letters to Katie Lewis*, London, 1925

William Michael Rossetti (ed.), *Pre-Raphaelite Diaries and Letters*, London, 1900

William Michael Rossetti, *Some Reminiscences*, New York, 1906

James Sambrook, *Pre-Raphaelitism: A Collection of Critical Essays*, Chicago, 1974

George Bernard Shaw, 'J.M. Strudwick', *Art Journal*, LIII, April 1891, 97-103

Robert de la Sizeranne, *La Peinture Anglaise Contemporaine*, Paris, 1895

Allen Staley, *The Pre-Raphaelite Landscape*, Oxford, 1973

Frederick George Stephens, 'William Davis, Landscape Painter, of Liverpool,' *Art Journal*, 1884, 325-8

A.M.W. Stirling, *William de Morgan and his Wife*, London, 1922

Virginia Surtees, *The Paintings and Drawings of D.G. Rossetti: A Catalogue Raisonné*, Oxford, 1971

E.P. Thompson, *William Morris, Romantic to Revolutionary*, London, 1955

Julian Treuherz, *Pre-Raphaelite Paintings from the Manchester City Art Gallery*, Manchester, 1980

Raleigh Trevelyan, *A Pre-Raphaelite Circle*, London, 1978

Raymond Watkinson, *Pre-Raphaelite Art and Design*, London, 1970

Raymond Watkinson, *Frederick Sandys* (catalogue of an exhibition organized by Brighton Museum and Art Gallery), 1974

Aubrey Williamson, *Artists and Writers in Revolt: The Pre-Raphaelites*, London, 1976

G.C. Williamson, *Murray Marks and His Friends*, London, 1919

The Pre-Raphaelites (catalogue of an exhibition at the Tate Gallery, London), 1984

List of Illustrations

Colour Plates

26. William Morris
Queen Guenevere
1858. Oil on canvas. Tate Gallery, London

27. Ford Madox Brown
Pretty Baa-Lambs
1851-9. Oil on canvas. By courtesy of Birmingham
Museums and Art Gallery

28. Dante Gabriel Rossetti
Sir Galahad at the Ruined Chapel
1859. Watercolour on paper. By courtesy of
Birmingham Museums and Art Gallery

29. Arthur Hughes
The Long Engagement
1859. Oil on canvas. By courtesy of Birmingham
Museums and Art Gallery

30. William Holman Hunt
The Finding of the Saviour in the Temple
1854-60. Oil on canvas. By courtesy of Birmingham
Museums and Art Gallery

31. William Bell Scott
Detail from 'Iron and Coal'
1855-60. Oil on canvas. The National Trust,
Wallington Hall

32. Ford Madox Brown
Walton-on-the-Naze
1859-60. Oil on canvas. By courtesy of Birmingham
Museums and Art Gallery

33. William Bell Scott
Algernon Charles Swinburne
1860. Oil on canvas. Balliol College, Oxford

34. Arthur Hughes
The Knight of the Sun
1860. Oil on canvas. Private collection

35. William Davis
At Hale, Lancashire
1860. Oil on board. Walker Art Gallery, Liverpool

36. William Windus
The Outlaw
1861. Oil on canvas. City of Manchester Art Galleries

37. William Dyce
George Herbert at Bemerton
1861. Oil on canvas. Guildhall Art Gallery,
City of London

38. William Holman Hunt
London Bridge on the Night of the Wedding of the
Prince and Princess of Wales
1863. Oil on canvas. Ashmolean Museum, Oxford

39. Dante Gabriel Rossetti
Beata Beatrix
1863. Oil on canvas. Tate Gallery, London

40. Frederick Sandys
Morgan-le-Fay
1864. Oil on panel.
By courtesy of Birmingham Museums and Art
Gallery

41. Ford Madox Brown
Work
1852-65. Oil on canvas. City of Manchester Art
Galleries

42. John Brett
February in the Isle of Wight
1866. Watercolour on paper. By courtesy of
Birmingham Museums and Art Gallery

43. Edward Burne-Jones
Phyllis and Demophoon
1870. Gouache on paper. By courtesy of Birmingham
Museums and Art Gallery

44. Dante Gabriel Rossetti
The Blessed Damozel
1871-7. Oil on canvas. By courtesy of the Fogg Art
Museum, Grenvill L. Winthrop Bequest, Harvard
University

45. Edward Burne-Jones
The Arming of Perseus
1877. Tempera on canvas.
Southampton Art Gallery

46. Evelyn de Morgan
Flora
c.1880. Oil on canvas. By courtesy of the trustees of
the De Morgan Foundation

47. John Melhuish Strudwick
The Gentle Music of a Byegone Day
1890. Oil on canvas. Private collection

48. John Byam Shaw
The Boer War
1901. Oil on canvas. By courtesy of Birmingham
Museums and Art Gallery

Text Illustrations

1. Photograph of Dante Gabriel Rossetti,
 October 1863
 Taken by Lewis Carroll. Humanities Center,
 Gernsheim Collection, University of Texas

2. James Collinson
 Detail from 'The Renunciation of Queen Elizabeth
 of Hungary'
 1848-50. Oil on canvas. Johannesburg Art Gallery

3. Frederick George Stephens
 Mother and Child
 1845-50. Oil on canvas. Tate Gallery, London

4. John Everett Millais
 Caricature of a Post-Raphaelite Composition
 c.1848. Pen and ink on paper. By courtesy of
 Birmingham Museums and Art Gallery

5. Dante Gabriel Rossetti
 Complete Compositional Study for 'Found'
 c.1855. Pen and ink on paper. By courtesy of
 Birmingham Museums and Art Gallery

6. John Everett Millais
 Retribution
 1854. Pen and ink on paper. Maas Gallery, London.
 Photograph by kind permission of Christie's Ltd

7. Charles Allston Collins
 May, in the Regent's Park
 1851. Oil on canvas. Tate Gallery, London

8. George Price Boyce
 The Mill on the Thames at Mapledurham
 1860. Watercolour on paper. Fitzwilliam Museum,
 Cambridge

9. Photograph of William Morris and Edward
 Burne-Jones in the Garden of Burne-Jones'
 Home, 1874
 Hammersmith Public Libraries

10. Photograph of the Red House,
 Bexley Heath
 National Monuments Record, London

11. Photograph of Jane Morris Holding her
 Daughter, May Morris, c.1865
 William Morris Gallery, Walthamstow, London

12. The 'Sussex' Rush-Seated Chairs
 Page from a catalogue of Morris and Co., c.1910

13. Caricature of William Morris on a Pedestal,
 as an Orator
 Pencil on paper. By courtesy of Birmingham
 Museums and Art Gallery

Comparative Illustrations

38. William de Morgan
 Earthenware Dish
 c.1888. Painted in ruby lustre.
 Victoria and Albert Museum, London.
 Crown Copyright

39. John Melhuish Strudwick
 Acracia
 c.1888. Oil with gold on canvas.
 Photograph by courtesy of Julian Hartnell.
 Private collection, Germany

40. Photograph of the Dead in the Boer War
 National Army Museum, London

DANTE GABRIEL ROSSETTI (1828-82)
The Girlhood of Mary Virgin

1849. Oil on canvas, 83.2 x 65.4 cm. Tate Gallery, London

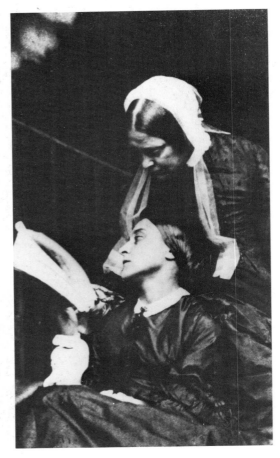

Fig. 14
Double Portrait
Photograph of
Christina Rossetti
and her Mother,
Mrs Gabriele
Rossetti

Taken by Lewis Carroll.
Private collection

The Girlhood of Mary Virgin was Rossetti's first completed oil painting, begun in the studio of Holman Hunt in the autumn of 1848 and supervised by both Hunt and Ford Madox Brown. Rossetti's mother was the model for St Anne and his sister Christina the model for the Virgin Mary (Fig. 14). The frame was originally inscribed with two sonnets by Rossetti, which explain the picture's symbols. The last four lines of the first sonnet (composed on 21 November 1848) describe *Ecce Ancilla Domini* (Plate 5), which was painted the following year.

This is that blessed Mary, pre-elect
God's Virgin. Gone is a great while, and she
Dwelt young in Nazareth of Galilee.
Unto God's will she brought devout respect
Profound simplicity of intellect,
And supreme patience. From her mother's knee
Faithful and hopeful; wise in charity;
Strong in grave *peace*; in pity circumspect.

So she held through her girlhood; as it were,
An angel-watered lily, that near God
Grows and is quiet. Till, one dawn at home
She woke in her white bed and had no fear
At all — yet wept till sunshine and felt awed:
Because the fullness of her time was near.

These are the symbols. On that cloth of red
I' the centre is the tripoint: perfect each,
Except the second of its points, to teach
That Christ is not yet born. The books — whose head
Is golden Charity, as Paul hath said —
Those virtues are wherein the soul is rich:
Therefore on them the lily standeth which
Is Innocence, being interpreted.

The seven-thorn'd briar, and the palm seven-leaved
Are her great sorrow and her great reward.
Until the end be full, the Holy One
Abides without. She soon shall have achieved
Her perfect purity: yea, God the Lord
Shall soon vouchsafe His Son to be her Son.

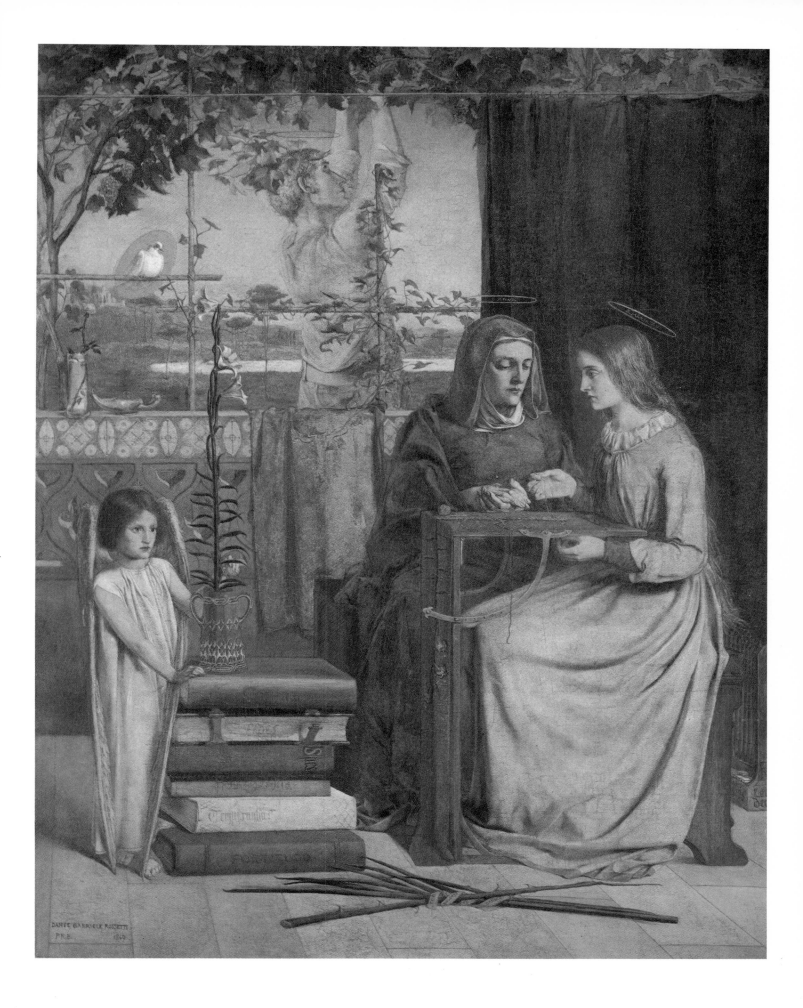

WILLIAM HOLMAN HUNT (1827-1910)
Claudio and Isabella

1849. Oil on panel, 75.8 x 52.5 cm. Tate Gallery, London

Hunt exhibited this work at the Royal Academy in 1853, with the following quotation from *Measure for Measure*:

Claudio: Ay, but to die, and go we know not where;
 'Tis too horrible!
 The weariest and most loathed worldly life,
 That age, penury, and imprisonment
 Can lay on nature, is a paradise
 To what we fear of death.

(Act III, scene i)

Hunt has chosen the moment when Claudio entreats his sister Isabella to sacrifice her virginity to her captor, so that his own life can be spared. Hunt returned to the theme of prostitution in a later canvas, *The Awakening Conscience* (Plate 15), and in this work he seems to support the conventional morality of saving Isabella's virginity rather than her brother's life. The issue however is complicated by the fact that in Hunt's day a woman's assertion of her chastity was one of the few means by which she could affirm her integrity as an individual in a society which still legally classified women with 'criminals, idiots and minors'. To remain pure, therefore, carries a political significance; it stands as a conscious rejection of exploitation and subjugation by the 'gentleman' classes and as an appeal for the essential humanity of womanhood, striving to survive independently of its usefulness to men. Hunt began the design for the painting in 1850 and painted it on a panel stripped from a 'superannuated coach'. He prepared the panel himself and hinge marks and fragments of paint are still discernible on the back.

JOHN EVERETT MILLAIS (1829-96)
Lorenzo and Isabella

1849. Oil on canvas, 99.1 x 142.9 cm. Walker Art Gallery, Liverpool

Fig. 15
John Everett
Millais
Study for the Head
of Isabella

1849. Pencil on paper,
34.9 x 24.1 cm. City Art
Gallery, Birmingham

Exhibited at the Royal Academy in 1849, this is the first work that Millais painted in accordance with the ideals of the newly formed Pre-Raphaelite Brotherhood. The first subject that the new group decided to tackle was a series of designs taken from Keats' *Isabella, or The Pot of Basil*. Millais chose the moment when Isabella's brothers were all gathered to eat, and the painting was exhibited with the following passage from Keats' poem:

> Fair Isabel, poor simple Isabel
> Lorenzo, a young palmer in Love's eye
> They could not long in the selfsame mansion dwell
> Without some stir of heart, some malady;
> They could not sit at meals but felt how well
> It soothed each to be the other by.
>
> These brethren having found many signs
> What love Lorenzo for their sister had
> And how she loved him, too, each unconfines
> His bitter thoughts to other, well-nigh mad
> That he, the servant of their trade designs,
> Should in their sister's love be blithe and glad
> When 'twas their plan to coax her by degrees
> To some high noble and his olive trees.

One important Pre-Raphaelite belief was that painting from friends produced a more intense and vivid likeness than painting from professional models; Millais used both friends and family as models in this work. The identity of some of the figures is open to doubt, but the more easily recognizable figures include those of D.G. Rossetti as the man at the end of the table, emptying a glass of wine with his head thrown back; Millais' sister-in-law, Mrs Hodgkinson, as Isabella (Fig. 15); William Michael Rossetti as Lorenzo; the artist's father as the man wiping his mouth with a napkin; and William Bell Scott as the serving man. Various symbols illustrate the antagonism of the brothers towards Lorenzo; the bird of prey perched behind one brother, the spilt salt on the table, the passion flowers and the pot of basil on the open terrace, the halved blood orange which Lorenzo offers to Isabella, and the brother who cracks a nut while viciously kicking Isabella's graceful dog.

JOHN EVERETT MILLAIS (1829-96)
James Wyatt and his Granddaughter Mary

1849. Oil on panel, 35.6 x 45.1 cm. Private collection

James Wyatt (1774-1855) was a picture-dealer and framemaker with premises at 115, High Street, Oxford. He was a prominent civic figure in Oxford and was Mayor of the city for 1842-3. He had purchased Millais' *Cymon and Iphigenia*, the painting Millais had worked on in 1847 for the Academy Exhibition of 1848, but which was in fact ultimately rejected by the hanging committee. Wyatt, however, was impressed with Millais' work and invited him to Oxford to paint this portrait of himself and his granddaughter Mary, as well as a companion piece, a portrait of Mrs James Wyatt and their daughter Sarah. Wyatt may well have been surprised as well as pleased with the result of these commissioned portraits. They show Millais' transition from the influence of the academicians such as William Etty, very much in evidence in *Cymon and Iphigenia*, to a remorseless solicitude for every minute detail of the subject he is painting. The china in the cabinet, the lacey knitting of the shawl antimacassar, the gilt barbola of the picture frames, the fallen petals of the flowers on the table, all show Millais adopting the heightened observation demanded by the Pre-Raphaelites. Although the glass-fronted china cabinet stands recessed in the corner of the room, and the Keepsake beauty in a roundel hangs on the back wall, there is only a small sense of depth to the room. The two figures stand out from their setting. All the other objects are of equal value, and James Wyatt and his granddaughter emerge from the room as part of an overall surface pattern.

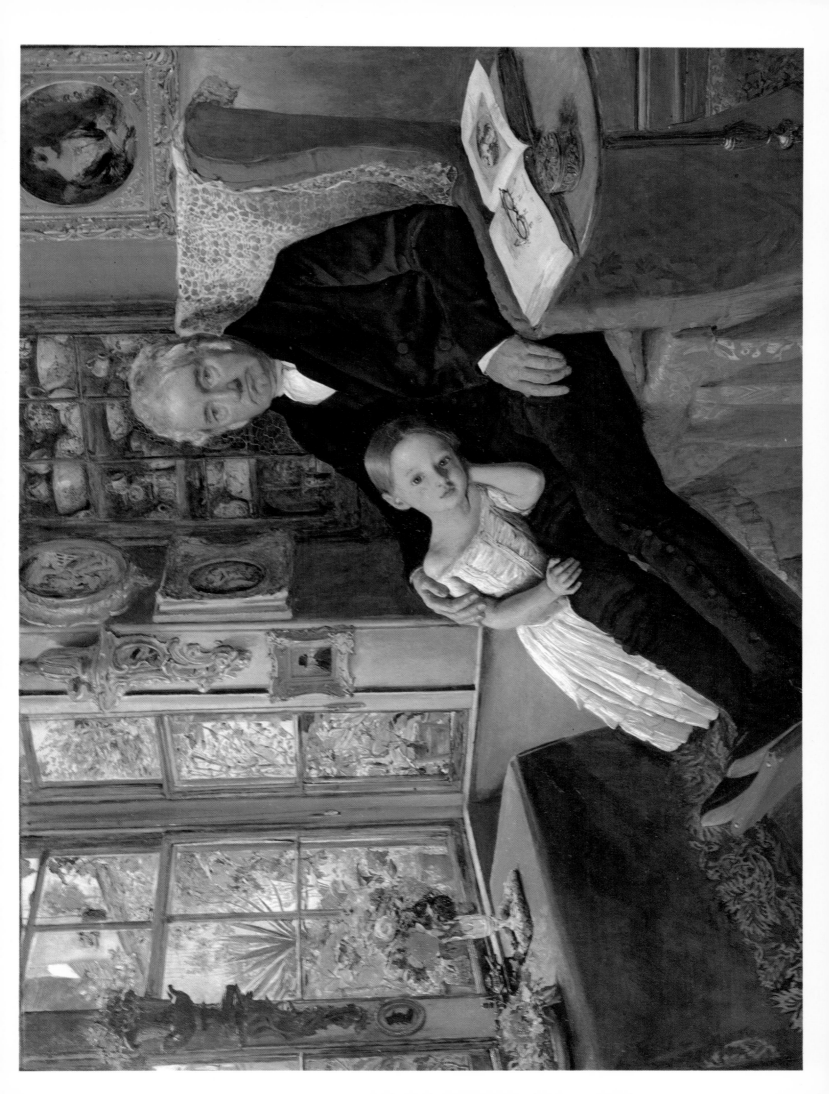

5 DANTE GABRIEL ROSSETTI (1828-82)
Ecce Ancilla Domini

1849-50. Oil on canvas, 72.4 x 41.9 cm. Tate Gallery, London

Abusive criticism greeted this work when it was first shown at the Portland Gallery in 1850. 'An example of the perversion of talent which has been recently making too much way in our school of Art', complained the *Athenaeum*; 'Mr. Dante Rossetti', protested the critic on *Blackwood's Magazine*, is 'one of the high-priests of this retrograde school ...'. Rossetti was so offended by the reception of this picture that, with few exceptions, he never again exhibited his work in public. What these critics did not appreciate were the innovations of this painting. Its shape is tall and narrow, suggestive of a slim gothic panel. Its colouring is predominantly white, picked out in red, gold and blue, all colours with time-honoured associations with Mary and the Virgin birth. Its iconography is odd: the Virgin is normally pictured reading at a prie-dieu, rather than being woken up in bed wearing a nightdress; the Angel Gabriel has flames at his feet, but no wings on his back. Rossetti's instincts were poetic, not narrative, and instead of meticulously recording the domestic details of the scene, with all the ritualistic gestures hallowed by the conventions of picture-making down the ages, he attempts to suggest, rather than illustrate, the miraculous atmosphere of the Annunciation.

It was also a particular difficulty for the mid-Victorian painter to paint a religious subject realistically. When the medieval artist dressed his religious figures in the clothes of his own period, it did not look ridiculous – every detail of daily life in the middle ages had an equivalent spiritual significance, which made religious painting, no matter how realistic, convincing. But to imagine a figure like Lord John Russell paying homage to the Infant Saviour, his top hat standing by on a pedestal, would not only be laughable, but pathetic, because by the mid-Victorian period an unbridgeable chasm had opened up between the facts of modern life and the depths that religion was supposed to touch. Rossetti recognized this problem, and in this picture of the Annunciation uses expressive colour and design to awaken the spectator to the same range of feelings that traditionally a representational painting of the subject encourages.

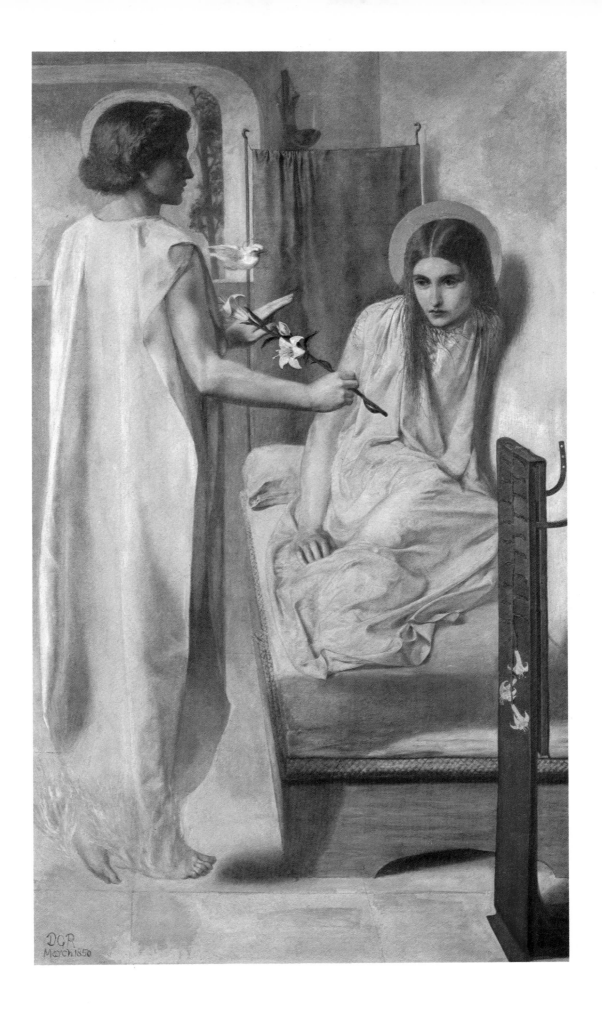

JOHN EVERETT MILLAIS (1829-96)
Christ in the House of his Parents

1849-50. Oil on canvas, 86.4 x 139.7 cm. Tate Gallery, London

In pursuit of the usual accuracy demanded by the Pre-Raphaelites, Millais painted this religious subject with a realism shocking to the contemporary public. *The Times* wrote that 'Mr. Millais' principal picture, is, to speak plainly, revolting. The attempt to associate the holy family with the meanest details of a carpenter's shop, with no conceivable omission of misery, dirt, or even disease, all finished with the same loathsome minuteness, is disgusting.' Charles Dickens writing in his *Household Words* deplored the fact that Mary looked like a 'monster in the vilest cabaret in France, or the lowest gin-shop in England'. He did admit though that 'the shavings which are strewn on the carpenter's floor are admirably painted'. Millais had gone to great lengths to depict the immediacy of the image. He modelled the body of St Joseph from a carpenter, to get the correct musculature, and drew the head from his father. Two sheep's heads were brought from a local butcher to draw the flock crowding in at the open door. Every detail of the picture was discussed by Millais, who was living at his parents' home while painting this work, with his family and not a stroke laid down on canvas without their approval. The painting was accompanied by the following passage from Zechariah (13.6):

> And one shall say unto him, What are these wounds in thine hands? Then he shall answer, Those with which I was wounded in the house of my friends.

Hunt recorded in his two-volume history of Pre-Raphaelitism (1905) that Millais had been inspired to paint the subject by a sermon he heard delivered on this text while he was staying at Oxford in the summer of 1849. The picture was started in the following autumn.

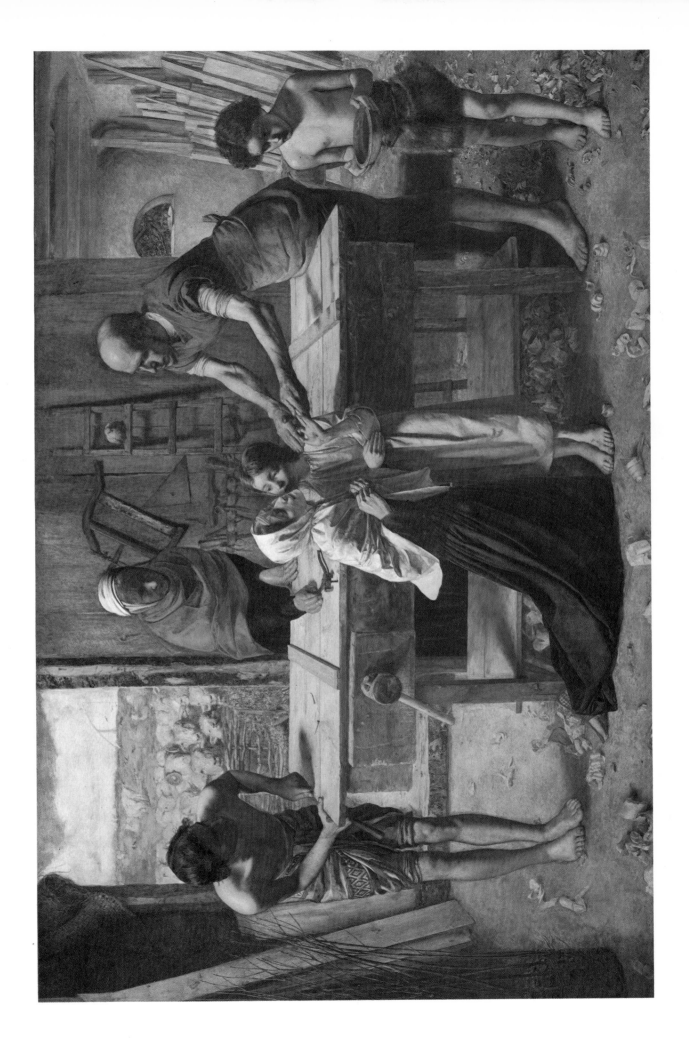

CHARLES ALLSTON COLLINS (1828-73)
Convent Thoughts

1850-1. Oil on canvas, 84 x 59 cm. Ashmolean Museum, Oxford

Fig. 16
John Everett
Millais (1829-96)
The Eve of St
Agnes

1854. Pen and ink,
25.7 x 21.6 cm.
Private collection

Charles Allston Collins, brother of the novelist Wilkie Collins and son of the academician William Collins, was a close friend of Millais but never a member of the Pre-Raphaelite Brotherhood. His leanings towards High Church ritual gave rise to hostile criticism in the press and, with this painting in particular, he was blamed for exhibiting all the worst features of Pre-Raphaelitism. 'It is in Mr Collins's choice of subjects generally', wrote David Masson in 1852 in *The British Quarterly Review*, 'that we discern something of that paltry affection for middle age ecclesiasticism with which the Pre-Raphaelites as a body have been too hastily charged. Little girls keeping their Chrisom pure against blue backgrounds, and other little girls kneeling on church-door steps to say their prayers; Puseyite clergymen may like such artistic helps towards teaching young ladies the way to a blessed life; but most decidedly the public is right in declaring that though the painting were never so good, it will not stand that sort of thing ... No; if we are to have religious paintings, let us have no more "Chrisoms pure", and other dear little adaptations of religion to the dilettantism of Belgravia.' This bright, awkward picture, however, won the approval of Ruskin who defended it in a letter to *The Times*, and railed against both the critics and the public for failing to see the 'finish of drawing and splendour of colour' in such an 'admirable though strange picture'.

Millais presented his drawing of *The Eve of St Agnes* (Fig. 16) to Effie Ruskin in February, 1854. The study of a nun sequestered in her cell and bound indoors by the snow illustrates Tennyson's lines from *St Agnes' Eve*:

Deep on the convent-roof the snows
Are sparkling to the moon:
My breath to heaven like vapour goes:
May my soul follow soon!

It is also an illustration of Millais' own pent-up feelings relating to his friendship with Ruskin's wife. Effie in fact recognized, in a letter to her mother, that the features of the nun were those of Millais himself: 'The Saint's face looking out on the snow with the mouth opened and dying-looking is exactly like Millais' — which however has not struck John who said the only part of the picture he didn't like was the face which was ugly but that Millais had touched it and it was better, but it strikes me very much.'

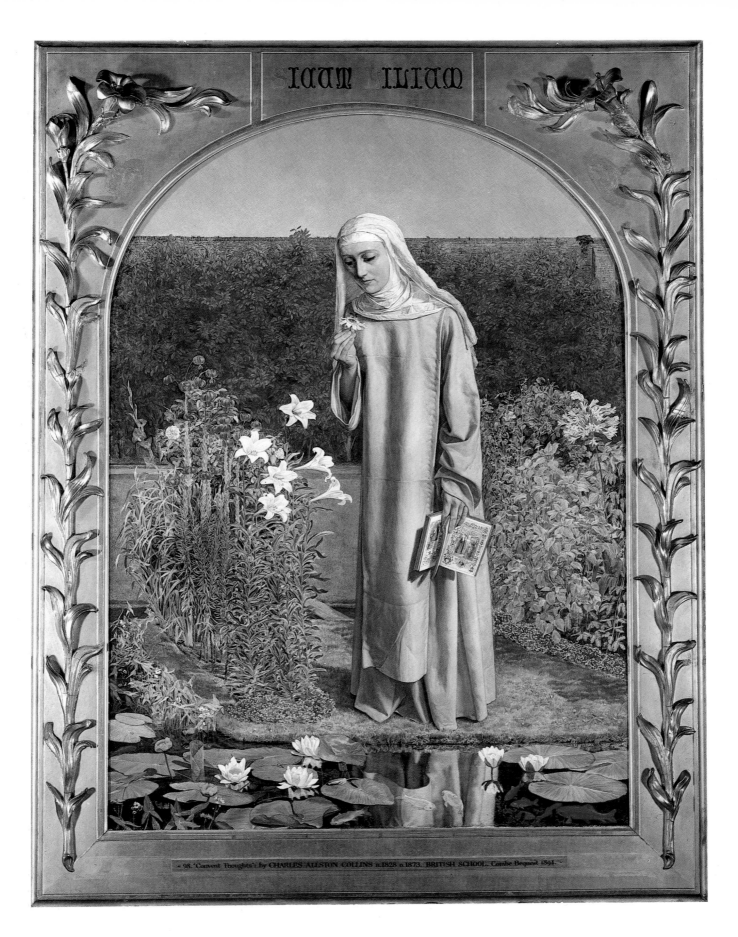

JOHN EVERETT MILLAIS (1829-96)
Mariana

1851. Oil on panel, 59.7 x 49.5 cm. From the Makins Collection

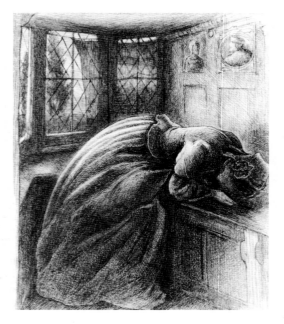

Fig. 17
John Everett
Millais
'Mariana'

1857. Wood engraving
illustrating 'I am aweary,
aweary!', in the Moxon
edition of Tennyson's
Poems, 1857

Shown at the Royal Academy in 1851 without a title, this picture was accompanied by the following lines from Tennyson's poem 'Mariana':

> She only said, 'My life is dreary —
> He cometh not' she said;
> She said, 'I am aweary, aweary —
> I would that I were dead'.

The awkwardness and angularity of Millais' first Pre-Raphaelite canvases, *Lorenzo and Isabella* (Plate 3) and *Christ in the House of his Parents* (Plate 6) are replaced in this work by a deep and gorgeous colouring and an easy, almost voluptuous rhythm. Most of the painting was completed in Oxford, with the stained glass painted from the windows of Merton College Chapel, and the scene through the window painted in the garden of his friend and patron, Mr Thomas Combe (printer to the University of Oxford). Even the velvet was bought from a local Oxford drapers. The lapidary richness of the surface, reminiscent of a bejewelled medieval manuscript, the choice of a sentimental moment from contemporary literature, the vaguely suggestive religious atmosphere and the exquisitely painted details of the mouse scratching on the bare floorboards, the desiccating leaves inside the room and the pliant supple leaves outside the window, all bring together the main features of Pre-Raphaelitism in its early days. The facility, however, of this painting, the sense that the subject is seen not felt, and its slightly phoney intensity, indicate the direction that Millais was to take later, after he separated from the Brotherhood in the late 1850s. His wood engraving illustrating 'Mariana' (Fig. 17), published in the Moxon edition of Tennyson of 1857, captures the claustrophobia of boredom with an elegant precision, and the subject suffers from none of the rich visual incident which tends to distract the attention in the oil version of the subject.

WILLIAM HOLMAN HUNT (1827-1910)
Valentine Rescuing Sylvia from Proteus

1851. Oil on canvas, 98.4 x 133.4 cm. City Art Gallery, Birmingham

Fig. 18
Elizabeth Siddal
(1834-62)
Self-Portrait

1853. Oil on canvas,
23 x 23 cm.
Private collection

'We cannot censure at present as amply or as strongly as we desire to do, that strange disorder of the mind or the eyes which continues to rage with unabated absurdity among a class of artists who style themselves P. R. B.' Such was the verdict of *The Times* on this work by Hunt. The subject is taken from *The Two Gentlemen of Verona*, Act V, scene iv, when Valentine shouts at Proteus, 'Ruffian, let go that rude, uncivil touch; Thou friend of an ill fashion!' The background was painted at Knole Park, Sevenoaks, in November 1850, Hunt 'painting the ground all covered with red autumn leaves', as Woolner reported to W.M. Rossetti. The dresses, hat and embroidery were all designed and made by Hunt himself, and the models were friends of the artist: James Aspinal, a barrister and journalist, sat for Proteus; James Lennox Hannay, also a barrister, a cousin of the writer James Hannay and an intimate of the Pre-Raphaelite circle, sat for Valentine, and Elizabeth Siddal was the model for Sylvia (Fig. 18). Despite adverse comment from *The Times*, the picture was awarded the annual prize of £50 at the Liverpool Academy, where it was shown in 1852. In 1857, when it was exhibited at the Manchester Art Treasures Exhibition, it was awarded the more dubious merit of having a satirical verse composed in its honour, contained in a volume of verse by one Tennyson Longfellow Smith of Cripplegate Within, and dedicated 'with profound admiration and awe, to that Greatest of Modern Poets, Philosopher Artists, Art-Critics, and Authors, The Immortal Ruskin':

And why are both the ladies fair?
Why's Proteus like a Sussex clod?
Any why have they all such curious hair?
Why's Julia's figure made so odd?

But ask no more what may be meant;
Remember, life is but a dream;
He doubtless wish'd to represent
Things which are not what they seem.

Ruskin had defended the painting against its detractors, claiming that there was little which 'for perfect truth, power and finish could be compared for an instant with ... the velvet on the breast and chain mail of the Valentine'.

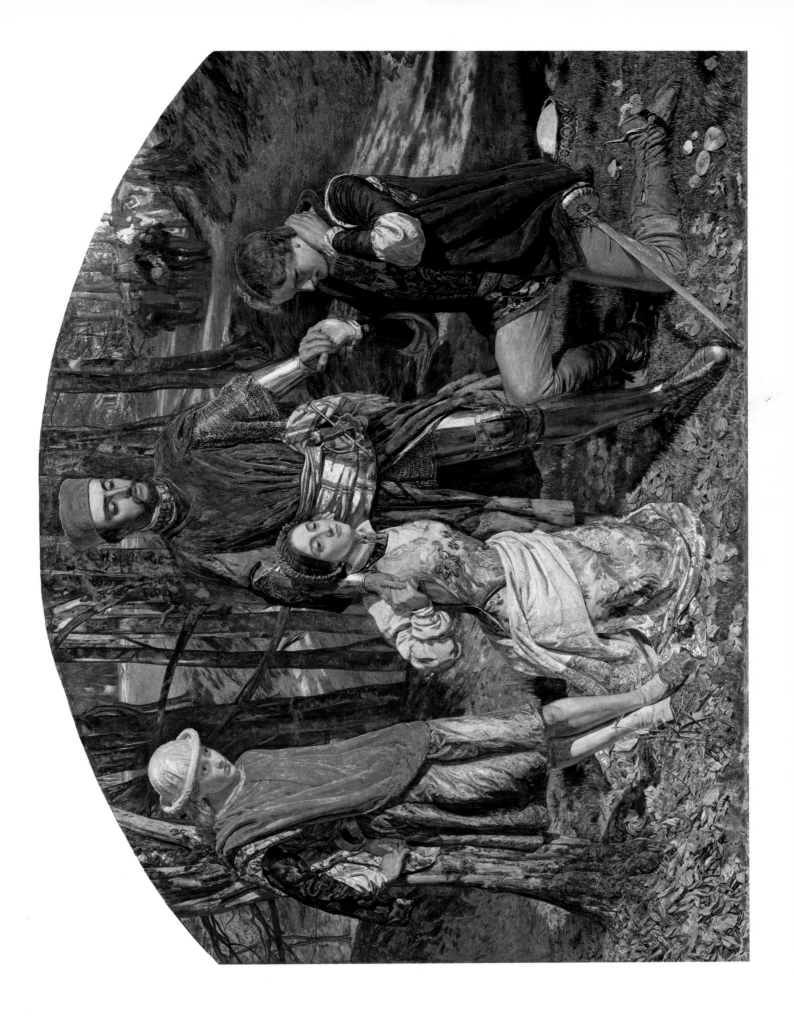

JOHN EVERETT MILLAIS (1829-96)
The Return of the Dove to the Ark

1851. Oil on canvas, 87.6 x 54.6 cm. Ashmolean Museum, Oxford

Millais' original plans for this picture were more ambitious than the completed version. 'The subject is quite new', he wrote to Thomas Combe, 'and I think, fortunate; it is the dove returning to the Ark with the olive branch. I shall have three figures — Noah praying, with the olive branch in his hand, and the dove in the breast of a young girl who is looking at Noah. The other figure will be kissing the bird's breast. The background will be very novel, and I shall paint several birds and animals one of which now forms the prey of the other.' Combe bought the painting immediately it was finished in April 1851, to the disappointment of Ruskin, who also wanted to purchase it, and who wrote to *The Times* after the Royal Academy exhibition of 1851, praising it fulsomely. 'Let the spectator contemplate', he wrote, 'the tender and beautiful expression of the stooping figure, and the intense harmony of colour in the exquisitely finished draperies; let him note also the ruffling plumage of the wearied dove, one of its feathers falling ... to the ground where the hay is painted not only elaborately but with the most perfect ease of touch and mastery of effect.'

Thomas Combe was also the purchaser of Hunt's *The Festival of St Swithin* (Fig. 19). This painting of doves in a dovecote was originally begun by Hunt's sister, but she abandoned it early on, finding it too difficult. 'It was not half completed', wrote Hunt, 'and this half was nearly all by my own hand. The dovecote was still in my garden ... together with the pigeons, and it seemed foolish to throw the work away.' It is one of Hunt's most atmospheric pictures, with the rain splattering down onto the roof of the dovecote (St Swithin being the patron saint of rain), ruffling the feathers of the birds and drizzling through the trees in the background.

Fig. 19
William Holman
Hunt (1827-1910)
The Festival of
St Swithin

1866-75. Oil on canvas,
73 x 91 cm. Ashmolean
Museum, Oxford

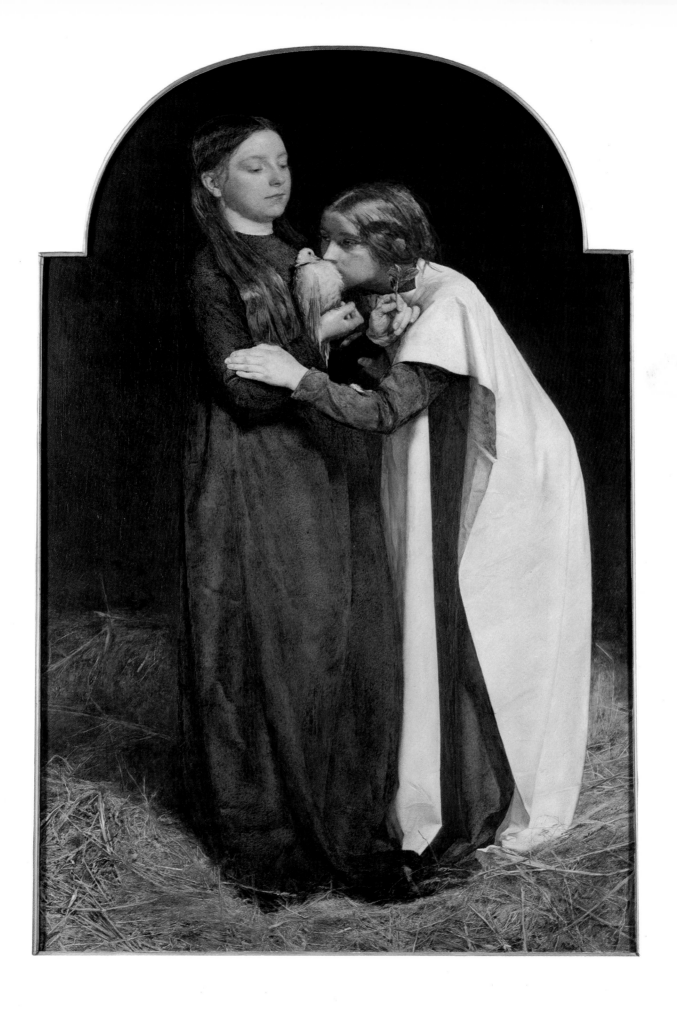

WILLIAM HOLMAN HUNT (1827-1910)
Detail from 'The Hireling Shepherd'

1851. Oil on canvas, 76.5 x 109.5 cm. City Art Gallery, Manchester

This painting (Fig. 20) was exhibited at the Royal Academy in 1852 with a quotation from Edgar's song in *King Lear*:

> Sleepest or wakest thou, jolly shepherd?
> Thy sheep be in the corn;
> And for one blast of thy minikin mouth,
> Thy sheep shall take no harm.

(Act III, scene iv)

Hardly the most obvious feature of the painting, the moral point was explained to the burghers of Manchester, when they acquired the painting in 1897: it was intended to be 'a rebuke to the sectarian vanities and vital negligencies ... Shakespeare's song represents a shepherd who is neglecting his real duty of guarding the sheep ... He was the type of muddle-headed pastors, who, instead of performing their services to the flock – which is in constant peril — discuss with questions of no value to any human soul. My fool has found a Death's Head Moth, and this fills his little mind with forebodings of evil, and he takes it to an equally sage counsellor for her opinion. She scorns his anxiety from ignorance rather than profundity, but only the more distracts his faithfulness. While she feeds her lamb with sour apples, his sheep have burst bounds and got into the corn. I did not wish to force the moral, and I never explained it till now. For its meaning was only in reserve for those who might be led to work it out. My first object as an artist was to paint, not Dresden china bergers, but a real shepherd, and a real shepherdess, and a landscape in full sunlight, with all the colour of luscious summer, without the faintest fear of the precedents of any landscape painters who had rendered Nature before.'

Fig. 20
William Holman
Hunt
The Hireling
Shepherd

1851. Oil on canvas,
76.5 x 109.5 cm. City Art
Gallery, Manchester

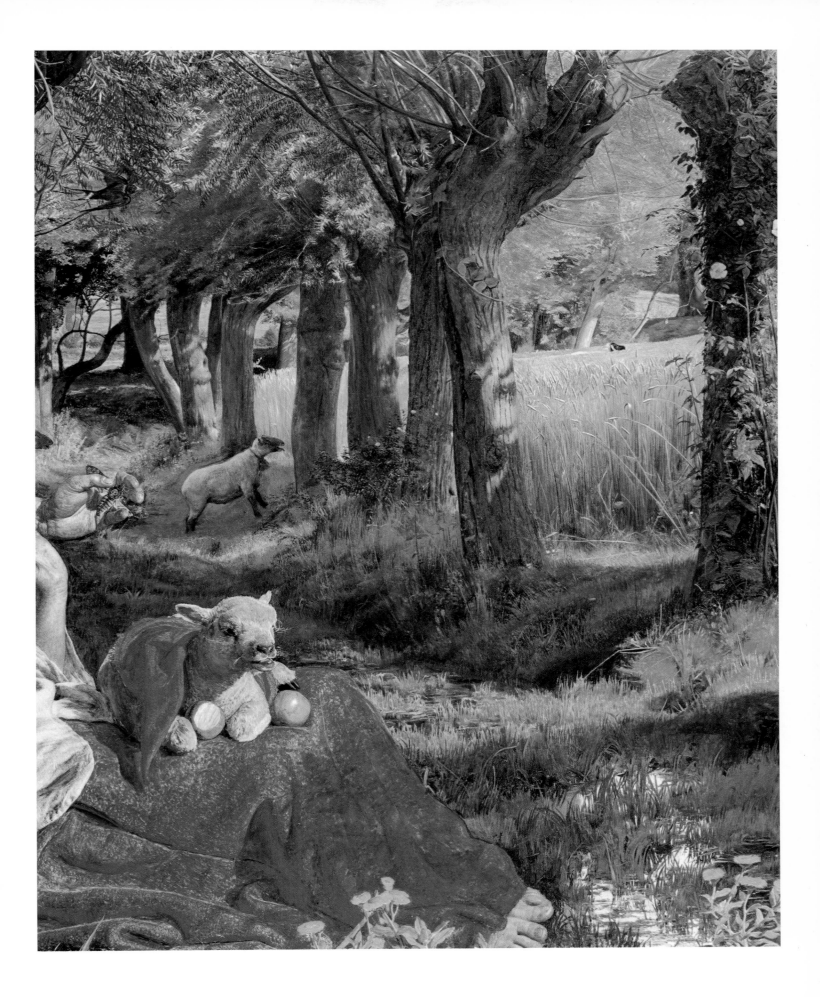

JOHN EVERETT MILLAIS (1829-96)
Ophelia

1851-2. Oil on canvas, 76.2 x 111.8 cm. Tate Gallery, London

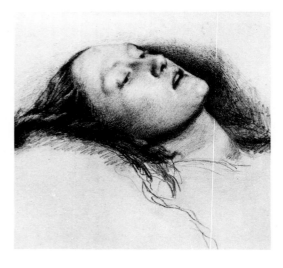

Fig. 21
John Everett
Millais
Study of Elizabeth
Siddal for the Head
of Ophelia

1851. Pencil on paper,
19 x 26.7 cm. City Art
Gallery, Birmingham

There is a willow grows aslant a brook
That shows his hoar leaves in the glassy stream;
There with fantastic garlands did she come,
Of crow-flowers, nettles, daisies, and long purples,
That liberal shepherds give a grosser name,
But our cold maids do dead men's fingers call them:
There, on the pendent boughs her coronet weeds
Clambering to hang, an envious sliver broke,
When down her weedy trophies and herself
Fell in the weeping brook. Her clothes spread wide,
And, mermaid-like, awhile they bore her up
...; but long it could not be
Till that her garments, heavy with their drink,
Pull'd the poor wretch from her melodious lay
To muddy death.

Queen Gertrude's description of Ophelia's death in *Hamlet*, Act IV, is the inspiration for Millais' painting. Unlike most other contemporary paintings based on Shakespearian themes, Millais' *Ophelia* is neither a *tableau vivant* nor is it particularly dramatic. Everything is relegated to the scintillating natural details of the scene. They form the real incident of the painting, and stand out like silk embroidery from the bed of weeds and grassy water plants in which the subject floats. Millais began work on the painting in the summer of 1851, painting the river and the background by the River Ewell near Kingston-upon-Thames. The outdoor location caused him some trouble. 'I sit tailor-fashion', he wrote, 'under an umbrella throwing a shadow scarcely larger than a halfpenny for eleven hours, with a child's mug within reach to satisfy my thirst from the running stream beside me ... am also in danger of being blown by the wind into the water, and becoming intimate with the feelings of Ophelia when that lady sank to muddy death.' His model for Ophelia, Elizabeth Siddal (Fig. 21; see also Fig. 18), also suffered fleshly mortifications when she sat for the picture. The painting was completed in London during the following winter and Miss Siddal had to lie in a bath of water, heated by oil lamps from below. The cold she caught as a result brought a complaint against the artist from Miss Siddal's father, with the threat for an action of £50 damages. The action was settled and Miss Siddal's portrait considered to be the best likeness ever painted of her.

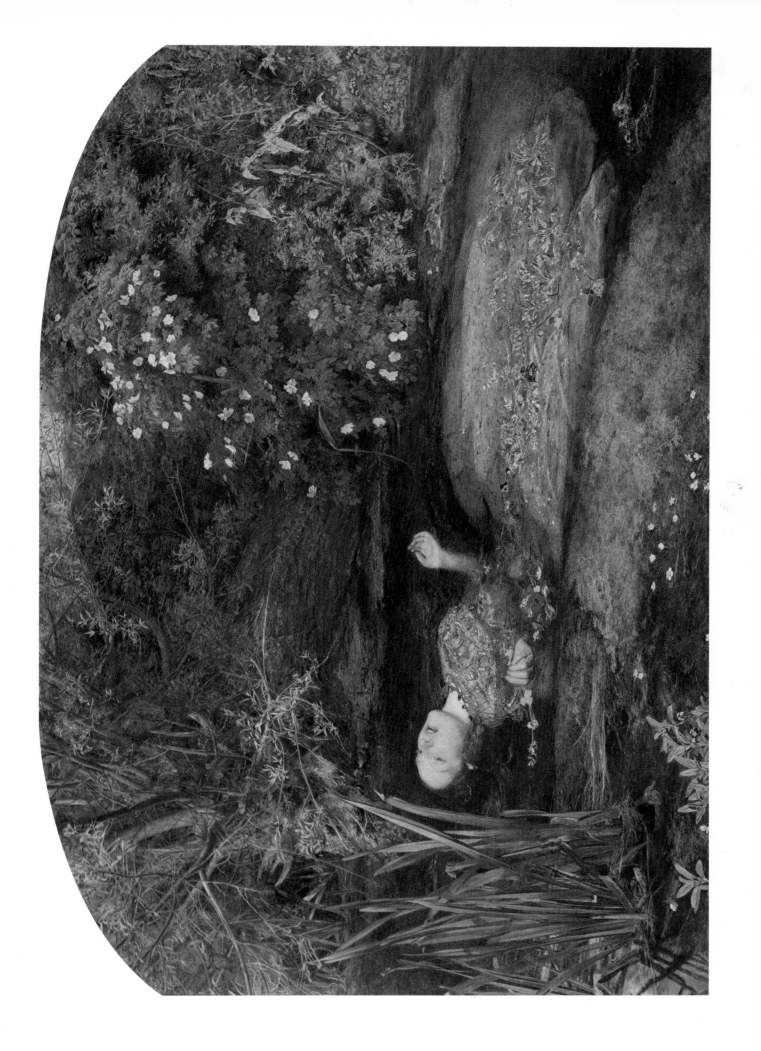

WILLIAM HOLMAN HUNT (1827-1910)
Our English Coasts

1852. Oil on canvas, 43.2 x 58.4 cm. Tate Gallery, London

Delacroix saw this painting at the Exposition Universelle in Paris in 1856 and declared, 'I am really astounded by Hunt's sheep.' It was hardly surprising. Hunt's canvas, painted in the summer and autumn of 1852 in Fairlight, near Hastings, was probably the brightest, most prismatic oil painting to be seen since Turner's late landscapes. The brilliance of the sun does not, as it was to do in Impressionist work, dissolve the objects it shines on, but emphasizes all their particular qualities: the thin membrane of a sheep's ear, the translucent wings of the butterflies, the flocked heads of docks and bedstraw. Hunt's study of what light does to colour is pursued into every tiny detail: the spots of red, pink, yellow and blue on the fleece of the sheep; the lavenders of brown, orange and blue on the mossy banks of the cliff. The earth is red in the sunlight, but turning to purple in the shadow; the cliff top is fresh green in the shade, but a limey yellow in the sunlight; above the cliffs the sky is bleached and almost white, but the sea to the left is broken into prisms of blue, green and violet. F.G. Stephens commented on the radical observations of light and colour that Hunt was making in this work: 'the sunlight lying upon the place was reflected into a whitish hazy glare, originated by the exhalations that arise from the cliff, which showed above and around it, softening the line of the horizon of the sea, though the cause is invisible, – a very subtle piece of observation, which we never remember to have seen painted before.' *Our English Coasts* is also known as *Strayed Sheep*, a title never given to it by Hunt, but one which reflects some of the religious overtones which were never far from Hunt's imagination: 'All we like sheep have gone astray' (Isaiah 53:6).

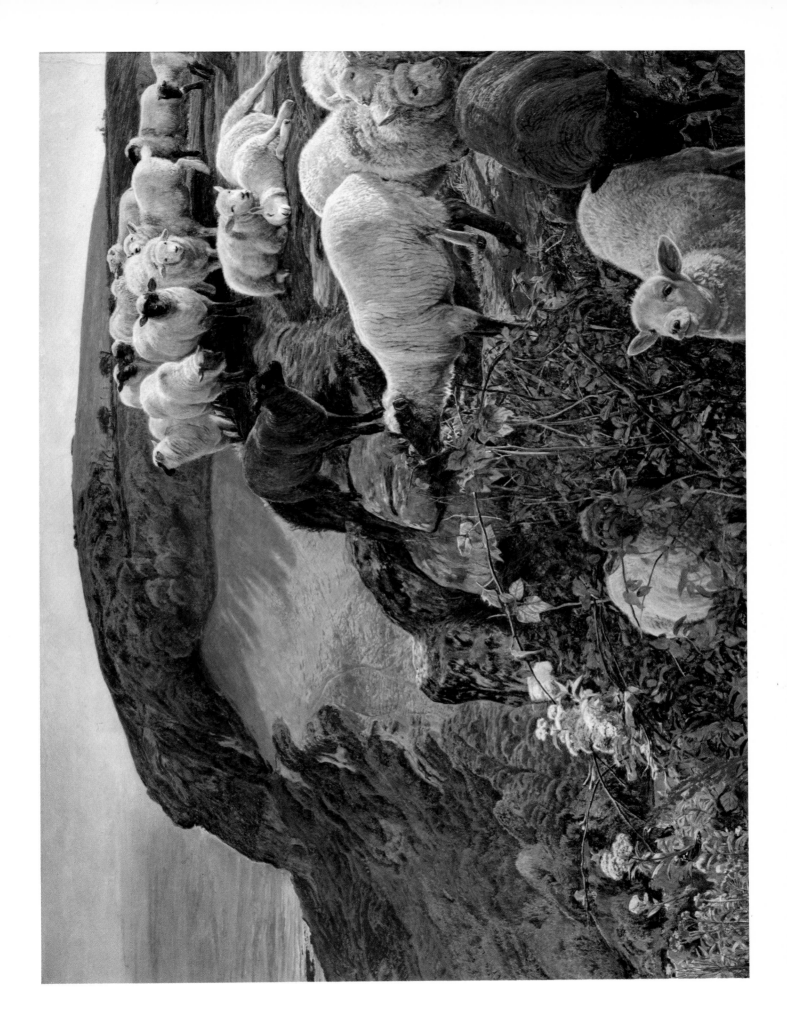

ARTHUR HUGHES (1830-1915)
Ophelia

1852. Oil on canvas, 68.6 x 123.8 cm. City Art Gallery, Manchester

By his own account Hughes was converted to Pre-Raphaelitism after reading *The Germ* when a third-year student in the Royal Academy schools. His work was most closely influenced by Millais, although curiously (having known Hunt, Rossetti and Brown for some time) he did not meet Millais until 1852, when they both had paintings entitled *Ophelia* (see also Plate 12) in the Royal Academy exhibition. Hughes' work was poorly placed, hung in the octagon room, commonly known by artists as 'the condemned cell'. Millais, however, spotted the picture and admired it. Hughes met him in front of the picture and later recalled that Millais 'had just been up a ladder looking at my picture, and that it gave him more pleasure than any picture there, but adding very truly that I had not painted the right kind of stream'. In fact the stream and strewn flowers are the most convincingly Pre-Raphaelite portions of the work – tightly painted and clear. The rest is moody, its misty greens and dusty reds suggestive, rather than illustrative, of the sad madness of Ophelia. During the 1850s when he was working under the aegis of the Pre-Raphaelites, Hughes produced his best paintings. The tendency to sentimentality and sweetness is kept in check by the tight and careful drawing of natural surroundings, and by the bright, definite colour of the details. Tenderness is their keynote. *Home from the Sea* (Fig. 22) was begun in 1856, painted from nature in the churchyard at Chingford, Essex. It was originally entitled *A Mother's Grave*, and included only the figure of the young boy. The boy's sister was added several years later, and introduces the note of mawkishness that was to mar Hughes' output from the mid-1860s.

Fig. 22
Arthur Hughes
Home from the Sea

1856-63. Oil on panel,
50.8 x 65.4 cm. Ashmolean
Museum, Oxford

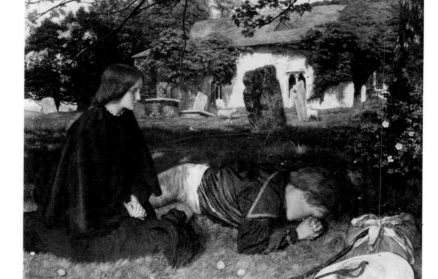

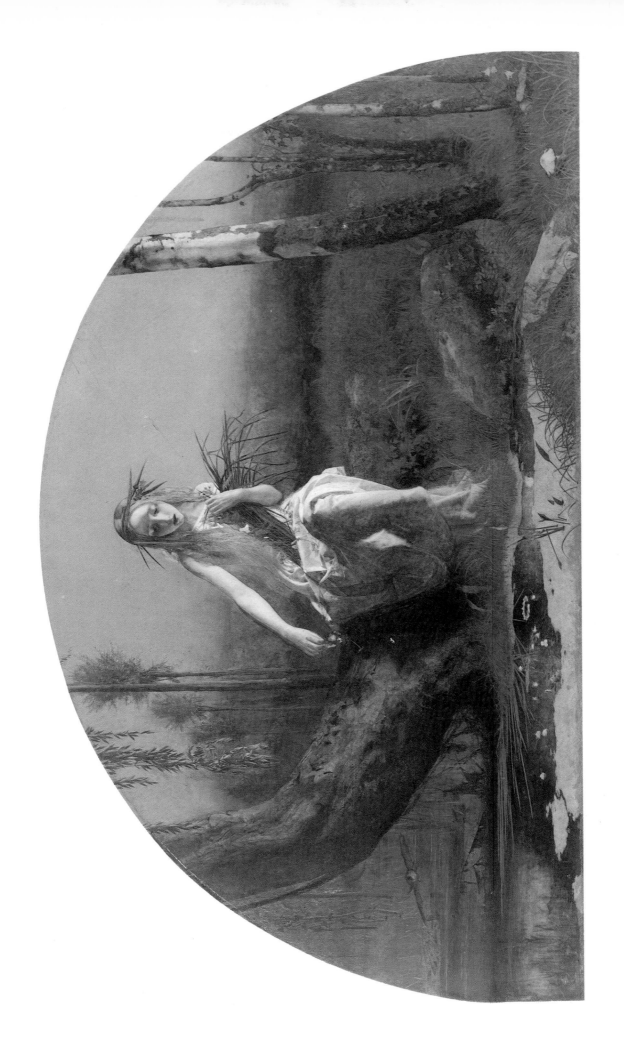

WILLIAM HOLMAN HUNT (1827-1910)
The Awakening Conscience

1853. Oil on canvas, 74.3 x 54.9 cm. Tate Gallery, London

Fig. 23
Photograph of
Annie Miller,
the Model for
'The Awakening
Conscience'

Private collection

The Pre-Raphaelites wanted to paint contemporary subjects and one of those they found most interesting was that of the fallen woman. Hunt claimed that his interest in the subject was aroused by reading the description of Old Peggotty's search for Little Emily in *David Copperfield*. He scoured the districts inhabited by fallen women, hoping to come across a suitable locality for a painting on the subject, but was one day reminded of a text from Proverbs: 'As he taketh away a garment in cold weather, so is he that singeth songs to a heavy heart.' 'These words', he wrote, 'expressing the unintended stirring up of the deeps of pure affection by the idle sing-song of an empty mind, led me to see how the companion of the girl's fall might himself be the unconscious utterer of a divine message.' Ironically, Hunt's model for the kept woman was Annie Miller (Fig. 23), a girl of easy virtue from the Chelsea slum of Cross Keys. Hunt fell in love with her and considered marrying her once he had managed to 'improve' her character. She proved unimprovable, though Hunt remained infatuated with her for several years. The accretion of symbolic objects in the newly furnished parlour adds at every point to the moral of the kept woman who suddenly, while sitting on her lover's knee, is struck with remorse and jumps up to throw off her guilty life and to follow henceforth in the paths of virtue: a bird is mauled by a cat under the table, tangled threads of embroidery wool lie on the floor, a single glove is thrown down at the woman's feet, a semi-clad female is trapped under the bell-jar on the piano holding time in her arms, the score to Tennyson's 'Tears, Idle Tears' lies abandoned on the carpet. Despite the moral message of the painting, most critics found the work obnoxious. 'Mr Hunt's second picture', declared the *Athenaeum*, 'is drawn from a very dark and repulsive side of domestic life.' Ruskin alone found the painting moving. 'That furniture,' he wrote, 'so carefully painted, even to the last vein of the rosewood — is there nothing to be learnt from that terrible lustre of it, from its fatal newness; nothing there that has the old thoughts of home upon it, or that is ever to become part of home?'

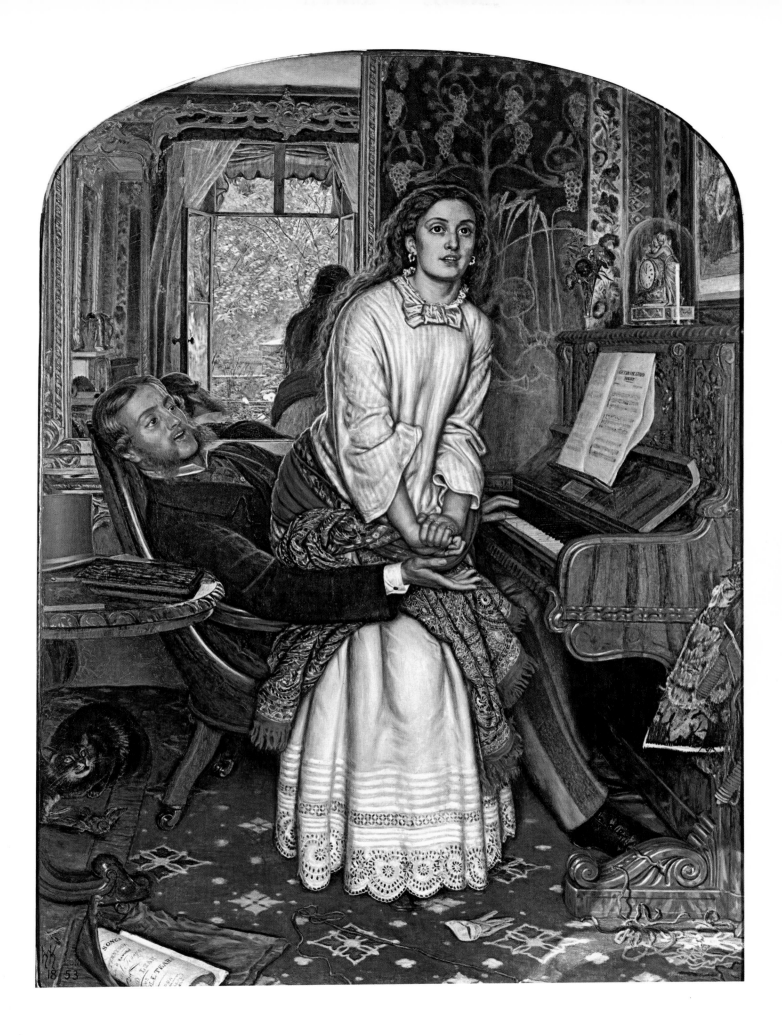

16 FORD MADOX BROWN (1821-93)
An English Autumn Afternoon

1852-4. Oil on canvas, 61.1 x 134.6 cm. City Art Gallery, Birmingham

Brown's largest landscape, this was painted from the back window of the artist's lodgings in Hampstead where he was living in 1852, 'intensely miserable, very hard-up, and a little mad'. It was not finished until early 1854, when it was sold at auction for nine guineas, 'the frame', according to Brown, 'having cost four'. Brown looked at landscape with all the care and Truth to Nature demanded by the Pre-Raphaelites, and, unlike most of the Brotherhood, painted it for its own sake, rather than as a backdrop. He was fierce in his defence of pure landscape when Ruskin asked him, apropos of *An English Autumn Afternoon*, 'Why did you choose such an ugly subject for your last picture?' 'Because it lay out of a back window', flashed Brown in retort. Brown himself described the picture as 'a literal transcript of the scenery round London, as looked at from Hampstead. The smoke rising halfway above the fantastic shaped, small distant cumuli, which accompany particularly fine weather. The upper portion of the sky would be blue, as seen reflected in the youth's hat, the grey mist of autumn only rising a certain height. The time is 3 p.m., when late in October the shadows already lie long, and the sun's rays (coming behind us in this work) are preternaturally glowing, as in rivalry to the foliage. The figures are peculiarly English — they are hardly lovers — mere boy and girl neighbours and friends.'

JOHN EVERETT MILLAIS (1829-96)
John Ruskin at Glenfinlas

1853-4. Oil on canvas, 78.9 x 67.9 cm. Private collection

In the summer of 1853 the Ruskins invited Millais and his brother to take a holiday with them in Scotland. They reached the Trossachs in July, and Millais immediately selected a bank of the river running through Glenfinlas as the background of this portrait of Ruskin. 'Millais has fixed his place,' wrote Ruskin to his father, 'a lovely piece of worn rock, with foaming water and weeds and moss, and a whole overhanging bank of dark crag.' Ruskin's own strong geological enthusiasms helped Millais in his decision, though Ruskin complained to his father some weeks later that 'as the picture stands at present I think there is little chance of its being done till near November. Everett never having painted rock foreground before did not know how troublesome it was.' Ruskin tried to help Millais with the background by drawing a study of gneiss rock for him (Fig. 24). The evolutionary significance of gneiss rock, with its characteristic metamorphic structure, cannot have been lost on Ruskin, though even older evolutionary forces were concurrently at work on Millais. He was falling in love with Mrs Ruskin, and she was responding to his passion. Greater than the difficulties of painting the foliated face of gneiss rock was Millais' problem in completing the portrait under such emotional strain. He did complete the painting, however, the following year, returning to Glenfinlas in May 1854 for a few last days among the rocks. After an annulment of her marriage to Ruskin was granted, Effie Ruskin married Millais on 3 July 1855, two years to the day after Millais had chosen Glenfinlas as a suitable spot for this portrait.

Fig. 24
John Ruskin
(1819-1900)
Study of Gneiss
Rock

1853. Ink and washes on
paper, 47.8 x 32.8 cm.
Ashmolean Museum,
Oxford

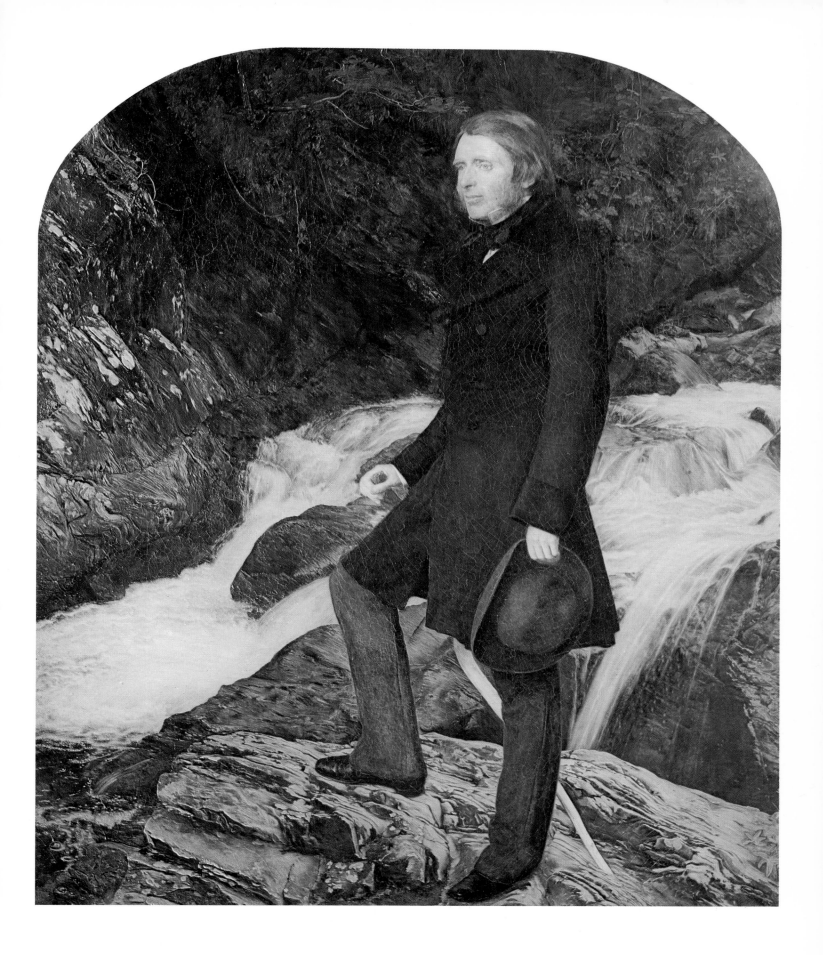

WILLIAM HOLMAN HUNT (1827-1910)
The Scapegoat

1854. Oil on canvas, 85.7 x 138.4 cm. Lady Lever Art Gallery, Port Sunlight, Liverpool

While studying books of Jewish ritual to prepare for the painting of *The Finding of the Saviour in the Temple* (Plate 30), Hunt became interested in the rituals of atonement as described in Leviticus, where, according to ancient Jewish lore, two goats were taken into the temple. One was ritually sacrificed as a burnt offering. The other, the scapegoat, was expelled into the wilderness, carrying with it the sins of the people. In the autumn of 1854, Hunt went down to the Dead Sea, to Osdoom, and, accompanied by only a few Arabs, sat at his easel in that desolation of sand, salt and wilderness to paint this picture. He painted with a rifle balanced on his knees, as a protection against bandits and preying animals. The Arabs who were with him were so impressed by his fortitude and his resolve that they suggested he might like to become their sheikh. In England, after the picture had been shown at the Royal Academy in 1856, the adulation was not so marked. Ruskin, who might normally be counted on to champion Pre-Raphaelite paintings, declared that: 'This picture, regarded merely as a landscape, or as a composition, is a total failure. The mind of the artist has been so excited by the circumstance of the scene, that, like a youth expressing his earnest feeling in feeble verse ..., Mr Hunt has been blinded by his intense sentiment to the real weakness of the pictorial expression; and in his earnest desire to paint a scapegoat, he has forgotten to ask himself first, whether he could paint a goat at all.'

FORD MADOX BROWN (1821-93)
The Last of England

1852-5. Oil on panel, 82.6 x 74.9 cm. City Art Gallery, Birmingham

At the height of the gold rush in 1852, Thomas Woolner emigrated to Australia to seek his fortune in the goldfields. Brown went to see him off at Gravesend, and seriously considered emigrating himself (to India), aggravated by poverty and lack of success. Instead, though, he went home to produce one of the most potent images of the mid-Victorian period. He depicts himself and his wife, Emma, of whom Fig. 25 is a study for the picture, as the emigrant couple and described the painting in the catalogue of his one-man show in 1865: 'It treats of the great emigration movement, which attained its culminating point in 1852. The educated are bound to their country by closer ties than the illiterate, whose chief consideration is food and physical comfort. I have, therefore, in order to present the parting scene in its fullest tragic development, singled out a couple from the middle classes, high enough, through education and refinement, to appreciate all they are giving up, and yet dignified enough in means to have put up with the discomforts and humiliations incident to a vessel "All one class" ... The husband broods bitterly over blighted hopes and severance from all that he has been striving for ... To insure the peculiar look of *light all round* which objects have on a dull day at sea, it was painted for the most part in the open air on dull days, and, when the flesh was being painted, on cold days. Absolutely without regard to the art of any period or country, I have tried to render this scene as it would appear. The minuteness of detail which would be visible under such conditions of broad daylight I have thought necessary to imitate as bringing the pathos of the subject home to the beholder.'

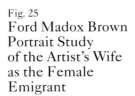

Fig. 25
Ford Madox Brown
Portrait Study
of the Artist's Wife
as the Female
Emigrant

1852. Black chalk on
paper, 16.5 x 17.8 cm. City
Art Gallery, Birmingham

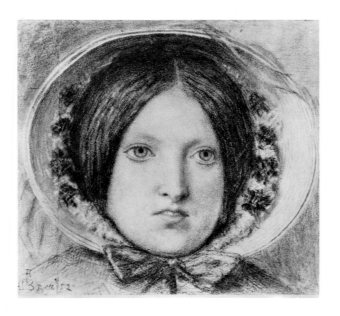

JOHN INCHBOLD (1830-88)
In Early Spring

1855. Oil on canvas, 50.8 x 34.3 cm. Ashmolean Museum, Oxford

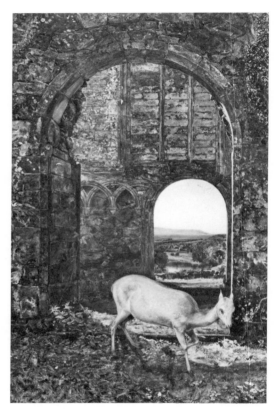

Fig. 26
John Inchbold
Detail from
'The White Doe of
Rylstone'

1855. Oil on canvas,
68.6 x 50.8 cm. Temple
Newsam House, Leeds

Wordsworth was the inspiration for both these paintings by Inchbold. *The White Doe of Rylstone* (Fig. 26), shown at the Royal Academy in 1855, and painted in Inchbold's native Yorkshire, at Bolton, illustrates the lines from Wordworth's poem of the same name:

> And through yon gateway, where is found,
> Beneath the arch with ivy bound,
> Free entrance to the churchyard ground,
> Comes gliding in with lovely gleam,
> Soft and silent as a dream
> A solitary Doe!

The undated picture, *In Early Spring*, is probably the picture Inchbold exhibited at the Royal Academy the same year under the title *A Study in March*. It was accompanied by Wordsworth's line, 'When the primrose flower peeped forth to give an earnest of the spring.' Primroses grow between the roots of the foreground tree with harebells and other spring flowers, and two newborn lambs frisk in the harsh March air — heralds of the springtime, the season of primroses. Most importantly, however, Wordsworth's attitude towards nature, as the outward clothing of inward spirits, comes alive in Inchbold's landscapes. Ruskin quoted a passage from Wordsworth in his first volume of *Modern Painters* and went on to say that 'the thoroughly great men are those who have done everything thoroughly, and who, in a word, never despised anything, however small, of God's making, and this is the chief fault of our English landscapists, that they have not the intense all-observing penetration of well-rounded minds'. Inchbold, though he painted with a painstaking exactness the facts of nature — the lichen, the mosses and the crumbling stone of Bolton Priory (as well as the little rabbit in the foreground), the spring flowers and the sapling branches of the early spring — nevertheless understood those facts as building blocks to a wider conception of nature, the nature of poetry and of imaginative inspiration.

21

JOHN EVERETT MILLAIS (1829-96)
The Blind Girl

1856. Oil on canvas, 82.6 x 61.6 cm. City Art Gallery, Birmingham

This painting was begun in the autumn of 1854 at Winchelsea, and completed two years later near Millais' home in Perthshire. His wife, Effie, sat for the blind girl. The Liverpool Academy in 1857 awarded it the annual prize; D.G. Rossetti found it 'one of the most touching and perfect things I know'. But it was Ruskin who came closest to describing its luminous visual qualities: 'The common is a fairly spacious bit of ragged pasture, and at the side of the public road passing over it the blind girl has sat down to rest awhile. She is a simple beggar, not a poetical or vicious one — a girl of eighteen or twenty, extremely plain-featured, but healthy, and just now resting, not because she is much tired but because the sun has but this moment come out after a shower, and the smell of the grass is pleasant. The shower has been heavy, and is so still in the distance, where an intensely bright double rainbow is relieved against the departing thunder-cloud. The freshly wet grass is all radiant through and through with the new sunshine; the weeds at the girl's side as bright as a Byzantine enamel, and inlaid with blue veronica; her upturned face all aglow with the light which seeks its way through her wet eyelashes. Very quiet she is, so quiet that a radiant butterfly has settled on her shoulder, and basks there in the warm sun. Against her knee, on which her poor instrument of beggary rests, leans another child, half her age — her guide. Indifferent this one to sun or rain, only a little tired of waiting.'

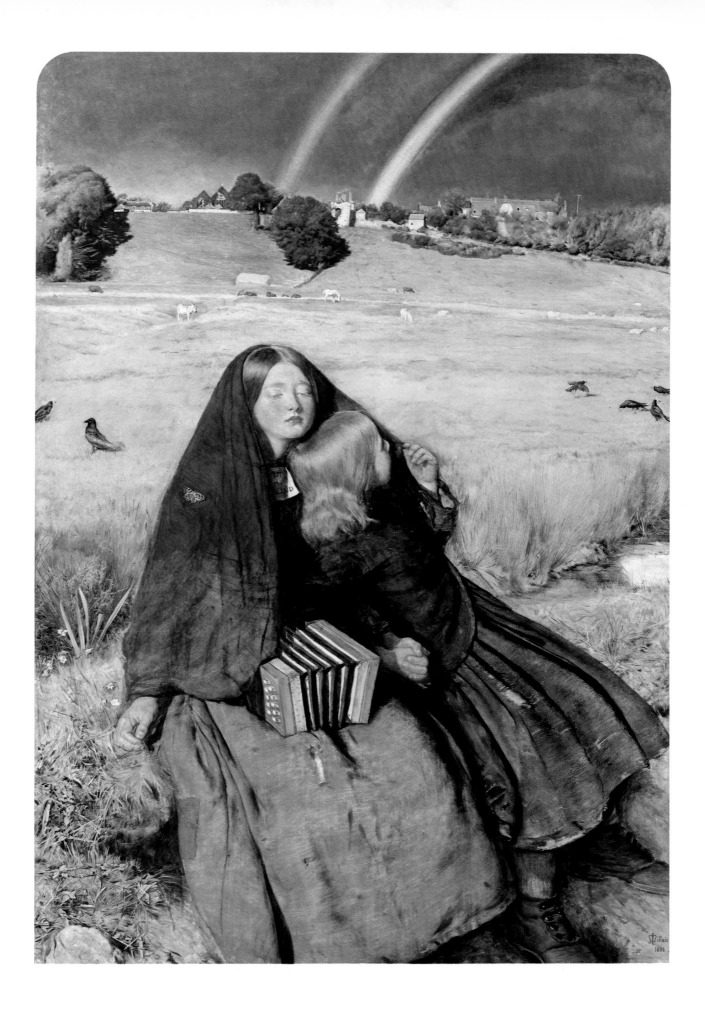

JOHN EVERETT MILLAIS (1829-96)
Autumn Leaves

1855–6. Oil on canvas, 104.1 x 74 cm. City Art Gallery, Manchester

Holman Hunt records a conversation he held with Millais in the autumn of 1851, in which Millais said to him, 'Is there any sensation more delicious than that awakened by the odour of burning leaves? To me nothing brings back sweeter memories of the days that are gone; it is the incense offered by departing summer to the sky; and it brings one a happy conviction that time puts a peaceful seal on all that is gone.' This painting was not begun until autumn 1855, in the garden of Annat Lodge, near Perth, where the recently married Millais and Effie lived for a short time following their wedding. The critic of the *Athenaeum* was perplexed by the painting's possible meaning: 'Of course there is some deep meaning in the season, moment, and even in the red hair, but we do not see it ...' Ruskin had to point it out to him in his *Academy Notes*: 'It is by far the most poetical work the artist has yet conceived; and also, as far as I know, the first instance of a perfectly painted twilight. It is easy, as it is common, to give obscurity to twilight, but to give the glow within the darkness is another matter; and though Giorgione might have come nearer the glow, he never gave the valley mist. Note also the subtle difference between the purple of the nearer range of hills and the blue of the distant peak.'

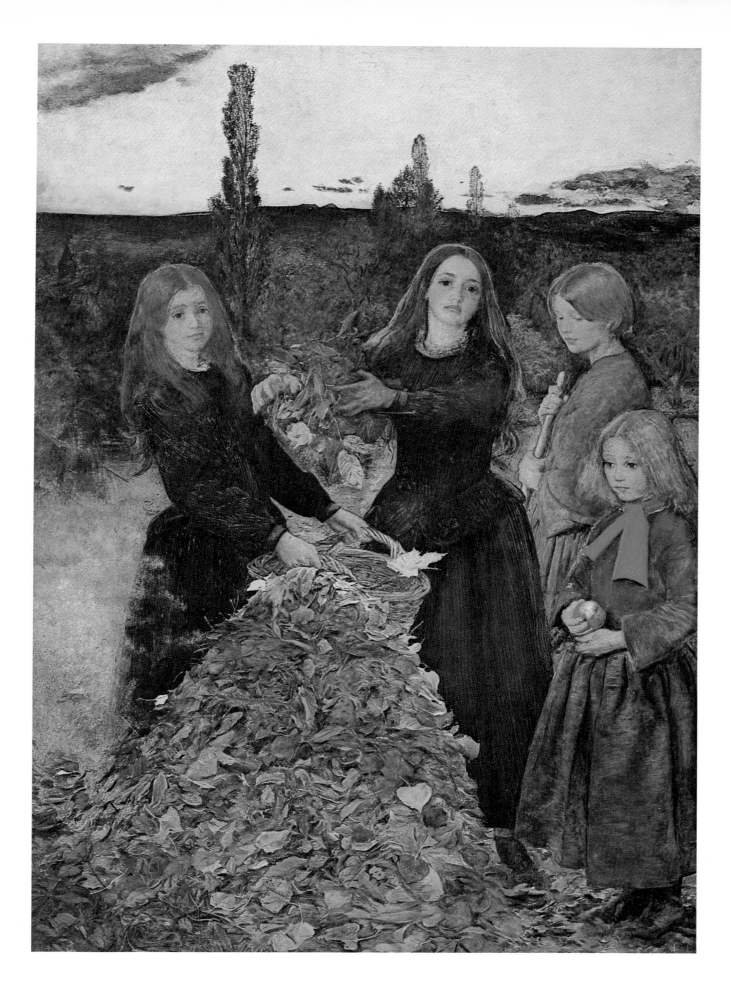

FORD MADOX BROWN (1821-93)
'Take your Son, Sir!'

1857. Unfinished, oil on canvas, 69.9 x 38.1 cm. Tate Gallery, London

The theme of social injustice, and of prostitution in particular, was one to which the Pre-Raphaelites turned on several occasions. Rossetti's picture, *Found* (Fig. 5), is his only work on a contemporary theme and illustrates the moment when a country drover, coming into London over Blackfriars Bridge, meets his former sweetheart, now a common prostitute. The interest in such subjects may have been the result of Henry Mayhew's *London Labour and the London Poor*, published in 1851, which told in graphic detail the injustices suffered by the poor, the innocent and the young. 'It has been proved', the report said, 'that 400 individuals procure a livelihood by trepanning females from eleven to fifteen years of age for the purposes of prostitution.' Rossetti was also probably influenced by Blake's *Songs of Experience*, but Madox Brown's sources for '*Take your Son, Sir!*' were more contemporary. A new divorce bill was passed in 1857, the date of this painting, in which for the first time women were able to sue for divorce, though only on the grounds of desertion and cruelty. The passing of the bill had been preceded by much public debate, and one of its loudest champions was Lady Caroline Norton, whose passionate fight to gain custody of her children after her husband had deserted her brought the question of legal justice within marriage and divorce to public attention. The illustration of 'unconsecrated passion within modern life', as Hunt called it, is taken by Brown in this painting to reveal the plight of the seduced. The wronged woman courageously exhibits her baby from the folds of her womb-like clothing to us, the watching audience, placing the responsibility both on the seducer (whose image is reflected in the round, halo-forming mirror behind her) and on society as a whole.

The model for the head of the prostitute in *Found* (Fig. 27), Fanny Cornforth, was Rossetti's housekeeper and mistress.

Fig. 27
Dante Gabriel
Rossetti (1828-82)
Study of Fanny
Cornforth for the
Prostitute's Head
in 'Found'

c.1860. Pen and ink on
paper, 17.8 x 19.7 cm. City
Art Gallery, Birmingham

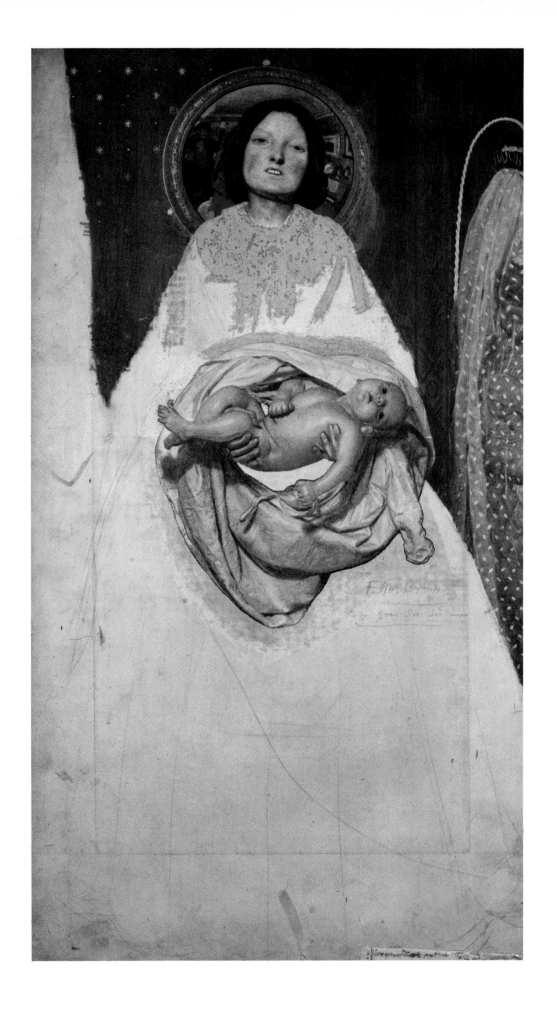

JOHN BRETT (1830-1902)
The Stonebreaker

1857-8. Oil on canvas, 49.5 x 67.3 cm. Walker Art Gallery, Liverpool

The lot of the stonebreaker has always been, from the time of the Pharaohs to the gangs of the Southern States and penal colonies of Australia, the lowest lot in society. The proletarian sympathies of the Pre-Raphaelite circle, as well as their desire to paint subjects from modern life, encouraged them to look at this most degraded form of labour. The most famous picture of stonebreakers, Courbet's painting of 1849, has a monumentality, a lack of idealization and sentimentality, and an immediacy that neither Brett nor Wallis could match. Wallis' painting (Fig. 28) was shown at the Royal Academy in 1858 with a quotation from Carlyle's *Sartor Resartus*: 'Hardly entreated, brother! For us was thy back so bent, for us were thy straight limbs and fingers so deformed; thou wert our conscript on whom the lot fell, and fighting for our battles wert so marred. For in thee too lay a God-created form, but it was not to be unfolded; encrusted must it stand with the thick adhesions and defacement of labour and thy body like thy soul was not to know freedom.' The painting, however, is so poetically beautiful in colour that the ignominy of the worker who dies while performing the most gratuitous and meaningless labour never really penetrates. Similarly, John Brett's stonebreaker, a pretty young boy almost as bright and delicate as the flowers in the serene and limpid landscape that surrounds him, cannot hope to communicate the crude, stark and uncompromising reality in which most of the urban proletariat worked.

Fig. 28
**Henry Wallis
(1830-1916)
The Stonebreaker**

1857. Oil on panel,
65.4 x 78.7 cm. City Art
Gallery, Birmingham

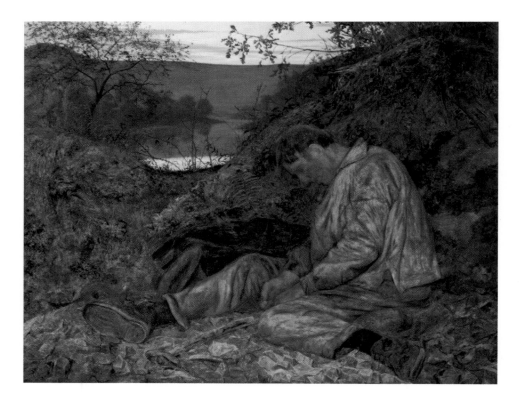

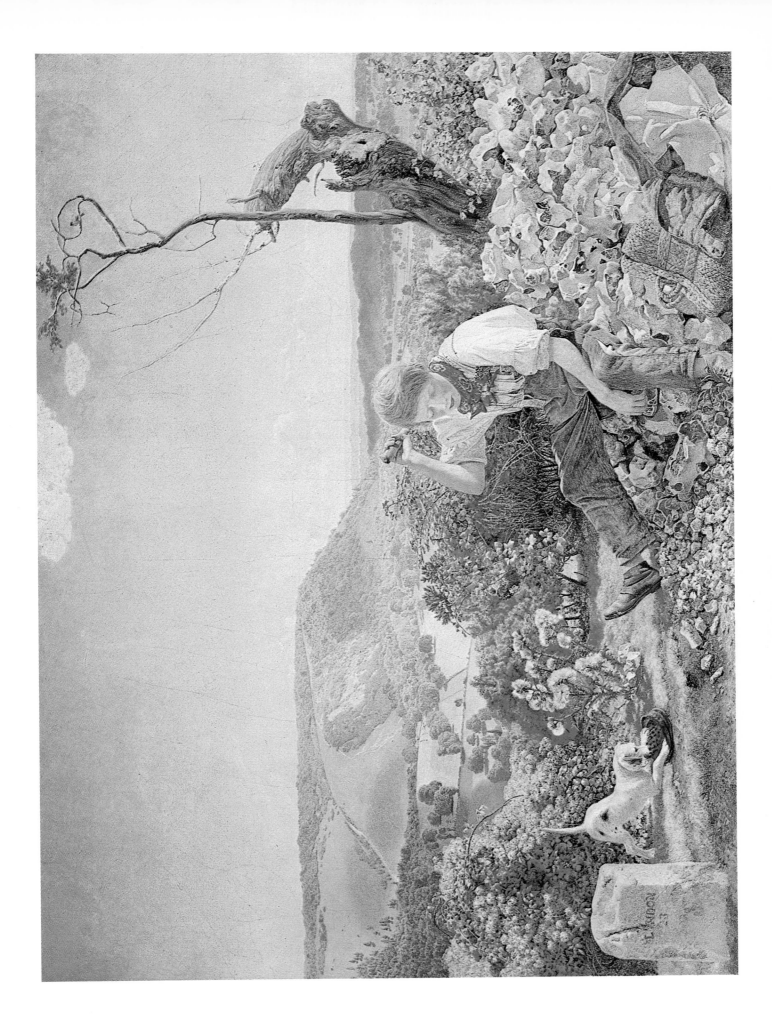

25

WILLIAM DYCE (1806-64)
Pegwell Bay, a Recollection of October 5th, 1858

1858. Oil on canvas, 63.5 x 88.9 cm. Tate Gallery, London

A generation older than the Pre-Raphaelites, Dyce met the German Nazarene painters in Rome in the 1820s, and was imbued with their ideas for the regeneration of art along the lines of early Christian painting. During the 1830s he was a successful portrait painter in Edinburgh; in the 1840s he undertook several fresco cycles in the House of Lords, Buckingham Palace and Lambeth Palace. In 1849 he was a member of the Hanging Committee of the Royal Academy and approved the selection of the new Pre-Raphaelite canvases of Hunt and Millais. Dyce also anticipated the Pre-Raphaelite interest in painting directly from nature, *en plein air*, when he proclaimed, in 1846: 'I suspect that we modern painters do not study nature enough in the open air, or in broad daylight.' Between 1855 and 1857, the influence of the Pre-Raphaelites and Holman Hunt in particular became manifest in his painting, and he emerged at the end of the period as one of the leading exponents of Pre-Raphaelite naturalism. In 1857 and 1858 the Dyce family took their annual holiday in Ramsgate, and here Dyce gathered material for the painting that was to become his masterpiece. On the very turning edge of late summer and early autumn, a few isolated figures wander over the shore. The tide is out. The flats are strewn with weed. The innocent figures collect pebbles, fish in the rock pool with their nets, wait patiently by the donkey rides. Overhead the ominous portent of Donati's comet flares through the sky. An artist on the far right of the picture strolls casually towards the grey, chalky cliffs. The most undramatic of scenes, Pegwell Bay is shot through with the sensation that nothing is more strange than the close observation of natural life.

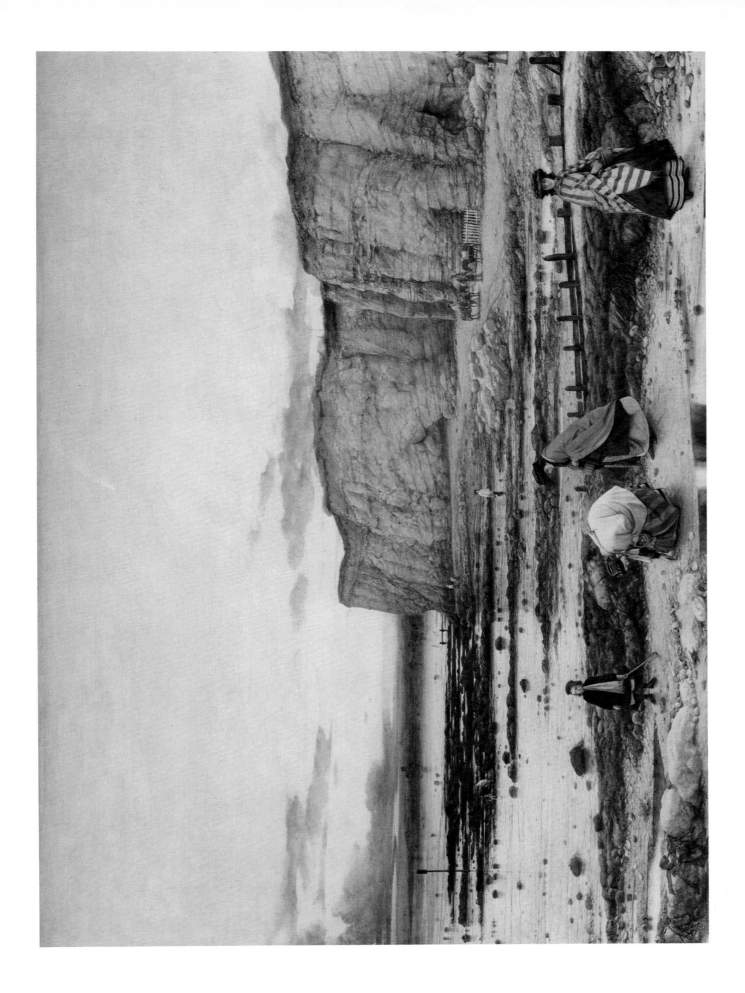

WILLIAM MORRIS (1834-96)
Queen Guenevere

1858. Oil on canvas, 71.8 x 50.2 cm. Tate Gallery, London

'Apart from the desire to produce beautiful things, the leading passion of my life has been and is hatred of modern civilisation ... Think of it! Was it all to end in a counting-house on the top of a cinder-heap, with Podsnap's drawing-room in the offing, and a Whig committee dealing out champagne to the rich and margarine to the poor in such convenient proportions as would make all men content together, though the pleasure of the eyes was gone from the world, and the place of Homer was to be taken by Huxley?' Morris wrote these lines in *How I became a Socialist*, two years before his death, but his whole life can be viewed as an attempt to create a world within worlds, where every value — whether it be that of architecture, domestic furniture or of personal relationships — was distinguished from the modern world in which he lived. His marriage to Jane Burden (Fig. 29) in 1859 was an example of the way he continually sought idealism, even within the most unromantic of relationships. Jane was a striking beauty, the bodily incarnation of perfect form. She was the model for this painting, the only easel painting Morris ever completed. Ironically, Jane Burden's identity with Queen Guenevere, the beautiful wife of a saintly king, was to become actual in real life, when her relations with Rossetti became intimate after 1868. The beautiful wife turned out to have less than ideal longings for the world of flesh and blood; the transition from romantic idealism to the warmth of real intimacy never occurred between Morris and his wife, and his idealizing attentions became fixed (with greater success) on the outer world.

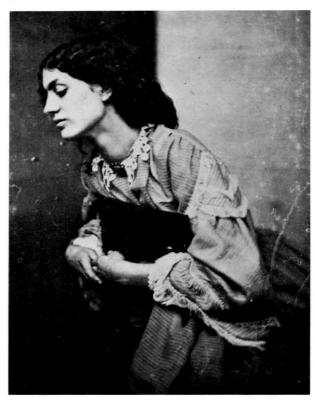

Fig. 29
**Photograph of
Jane Morris in 1865**

Photographed by Rossetti.
Victoria and Albert
Museum, London

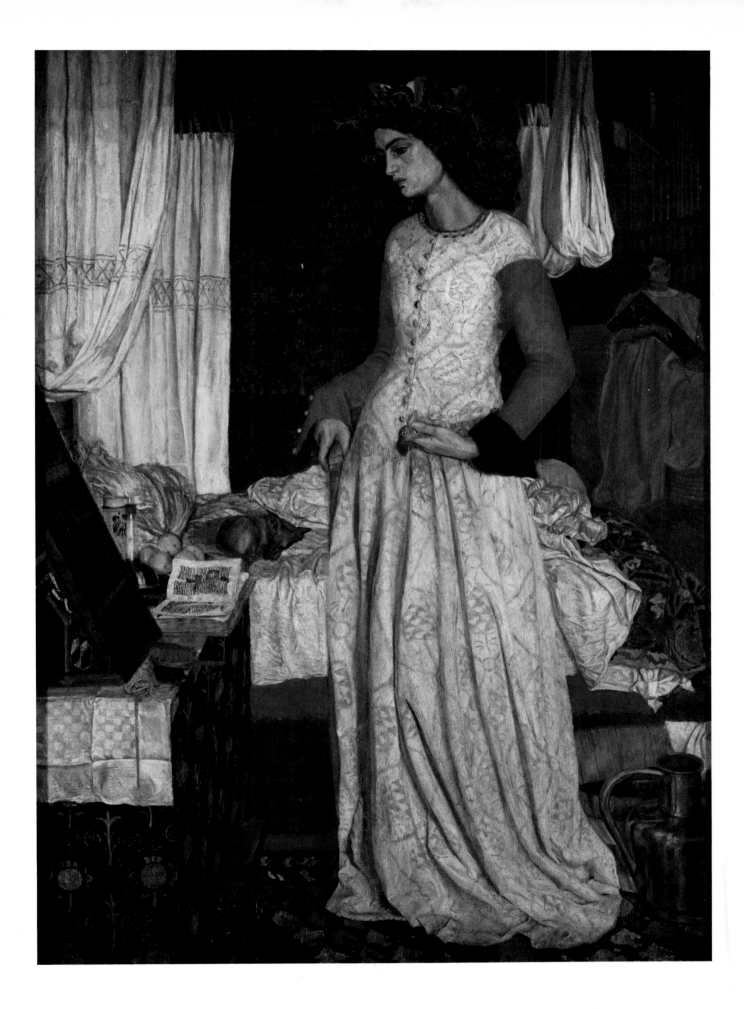

FORD MADOX BROWN (1821-93)
Pretty Baa-Lambs

1851-9. Oil on canvas, 59.7 x 74.9 cm. City Art Gallery, Birmingham

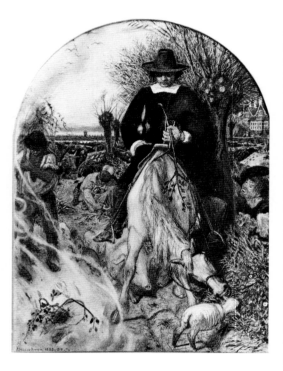

Fig. 30
Ford Madox Brown
Cromwell on his
Farm

1856. Watercolour and
pastel on paper,
34.3 x 24.8 cm. Whitworth
Art Gallery, University of
Manchester

Brown's first attempt at a *plein-air* landscape, *Pretty Baa-Lambs*, was begun out-of-doors in Stockwell in 1851. It mystified the critics when it was shown the following year at the Royal Academy, although Brown's explanations of its purpose were straightforward. In his diary of 1854 he recorded that: 'The Baa-Lambs picture was painted almost entirely in sunlight which twice gave me a fever while painting. I used to take the lay figure out every morning, and bring it in if it rained ... My painting room being on a level with the garden. Emma [his wife] sat for the lady, and Kate [his daughter] for the child. The lambs and sheep used to be brought every morning from Clapham Common in a truck: one of them ate up all the flowers one morning in the garden, and they used to behave very ill. The background was painted on the Common.' In 1865, when the painting was shown at the Piccadilly Gallery in a one-man show, Brown wrote in the catalogue, 'This picture was painted in 1851, and exhibited the following year, at a time when discussion was very rife on certain ideas and principles in art, very much in harmony with my own views, but more sedulously promulgated by friends of mine. Hung in a false light, and viewed through the medium of false ideas, the painting was, I think, much misunderstood. I was told it was impossible to make out what meaning I had in the picture. At the present moment, few people, I trust, will seek for any meaning beyond the obvious one, that is — a lady, a baby, two lambs, a servant maid, and some grass. In all cases, pictures must be judged first as pictures — a deep philosophical intention will not make a fine picture, such being given rather in excess of the bargain; and though all epic works of art have this excess, yet I should be much inclined to doubt the genuineness of the artist's ideas who never painted from love of the mere look of things, whose mind was always on the stretch for a moral. This picture was painted out in the sunlight; the only intention being to render the effect as well as my powers in a first attempt of that kind would allow.'

Brown began this study of *Cromwell on his Farm* (Fig. 30) when he visited St Ives in 1856 to look at the place where Cromwell spent the years of his political retirement before the outbreak of civil war, from 1631 to 1636. The subject was suggested by Brown's reading of Carlyle's second edition of *Cromwell's Letters and Speeches* (1846), which he found sympathetic to his own democratic views. In the picture 'the farmer is intended to foreshadow the king', he wrote, 'and everything is significant or emblematic.'

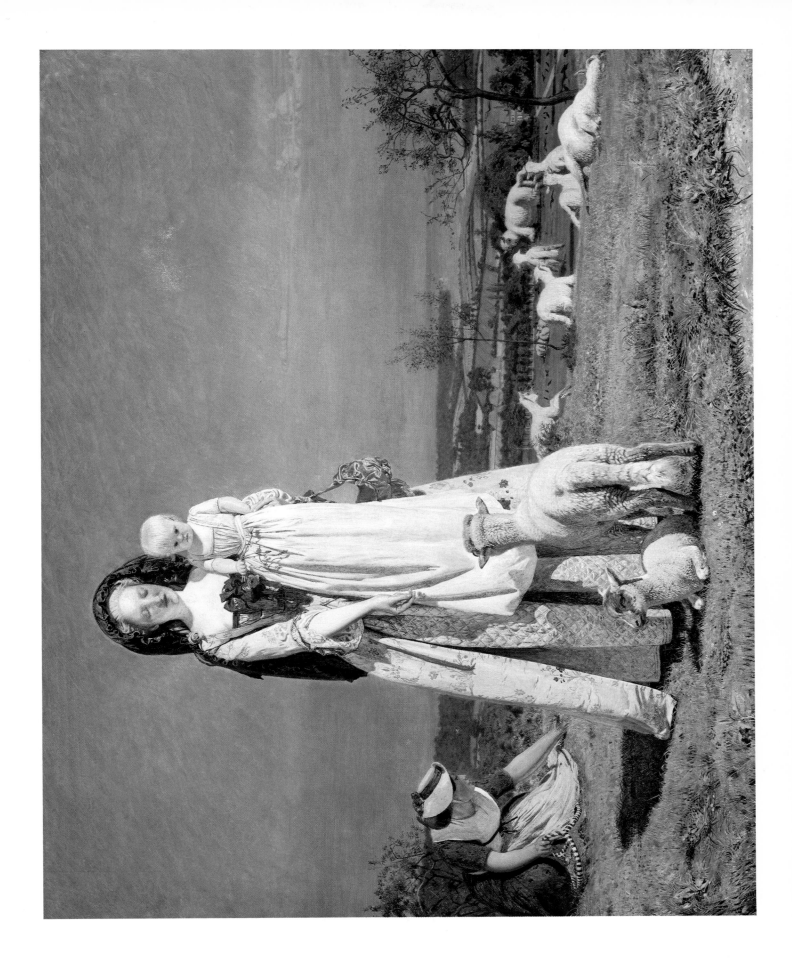

DANTE GABRIEL ROSSETTI (1828-82)
Sir Galahad at the Ruined Chapel

1859. Watercolour on paper, 29.2 x 34.3 cm. City Art Gallery, Birmingham

Rossetti produced five illustrations for the Moxon edition of Tennyson's *Poems*, published in 1857; this watercolour, for which there is no known drawing, was to illustrate Sir Galahad. Rossetti recognized that successful illustration did not necessarily mean the faithful transcription of the narrative of the poem into pictures, and he expressed his views on the subject in a letter to the poet William Allingham: 'I have not begun even designing them yet, but fancy I shall try the *Vision of Sin* and *Palace of Art*, etc. – those where one can allegorize on one's own hook, without killing for oneself and everyone a distinct idea of the poet's. This I fancy is always the upshot of illustrated editions – Tennyson, Allingham or anyone – unless where the poetry is so absolutely narrative as in the old ballads for instance.' Certainly in this watercolour, Rossetti is 'allegorizing on his own hook'. The knight has arrived at the chapel at the dead of night and Tennyson describes the scene before him in the following lines:

Between the dark stems the forest glows,
I hear a noise of hymns:
Then by some secret shrine I ride;
I hear a voice but none are there;
The stalls are void, the doors are wide,
The tapers burning fair.
Fair gleams the snowy altar-cloth,
The silver vessels sparkle clean,
The shrill bell rings, the censer swings,
And solemn chaunts respond between.

In Rossetti's version, the knight stands at the top of a flight of steps, kneeling in front of the altar and seemingly slaking his thirst by taking a drink from the vessel of holy water attached to a beam. A bevy of girls appears in the depths of the deserted chapel, the authors of the 'solemn chaunts'. Behind the midnight blooms the knight, wearing the 'mortal armour' of Tennyson's poem, rides noiselessly by.

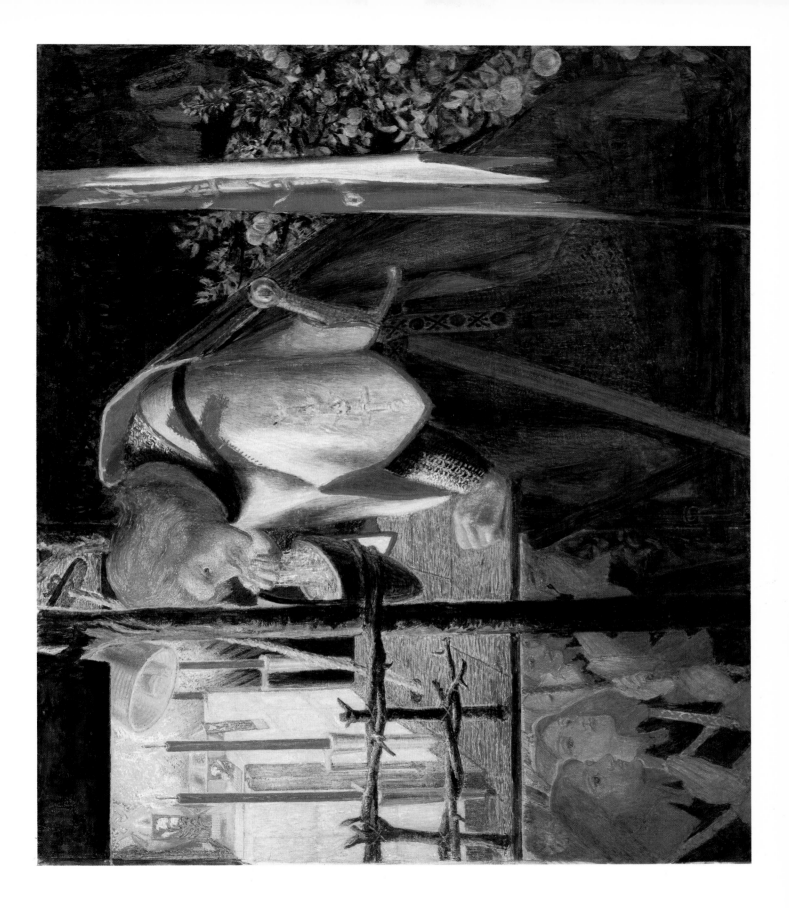

ARTHUR HUGHES (1830-1915)
The Long Engagement

1853–9. Oil on canvas, 105.4 x 52.1 cm. City Art Gallery, Birmingham

Hughes began this painting in 1853, as *Orlando in the Forest of Arden*. He took enormous trouble over the background, and in 1854 wrote to William Allingham about his struggles with nature: 'Painting wild roses into *Orlando* has been a kind of match against time with me, they passing away so soon, like all lovely things *under* the sun (eh?) and as sensitive as beautiful. The least hint of rain, just a dark cloud passing over, closes them up for the rest of the day perhaps. One day a great bee exasperated me to the pitch of madness by persisting in attacking me, the perspiration pouring down my face in three streams the while — and another I had to remain for three hours under a great beech tree with roots all unearthed and years upon years of dead leaves under his shade, listening to the rain plashings.' The painting, however, was rejected by the Royal Academy in 1855 and Hughes subsequently painted out Orlando and replaced him with a pair of patient lovers, their affections painfully attenuated while all around them nature blossoms, flourishes and reproduces itself in profusion. So long is the period of waiting that ivy has grown over the girl's name, Amy, carved into the bark of the tree at a time when presumably love was first promised. The painting was accepted by the Royal Academy in this form, and shown in 1859 with the following lines from Chaucer (*Troilus and Criseyde*):

For how myght sweetness ever hav be known
For hym that never tastyd bitternesse.

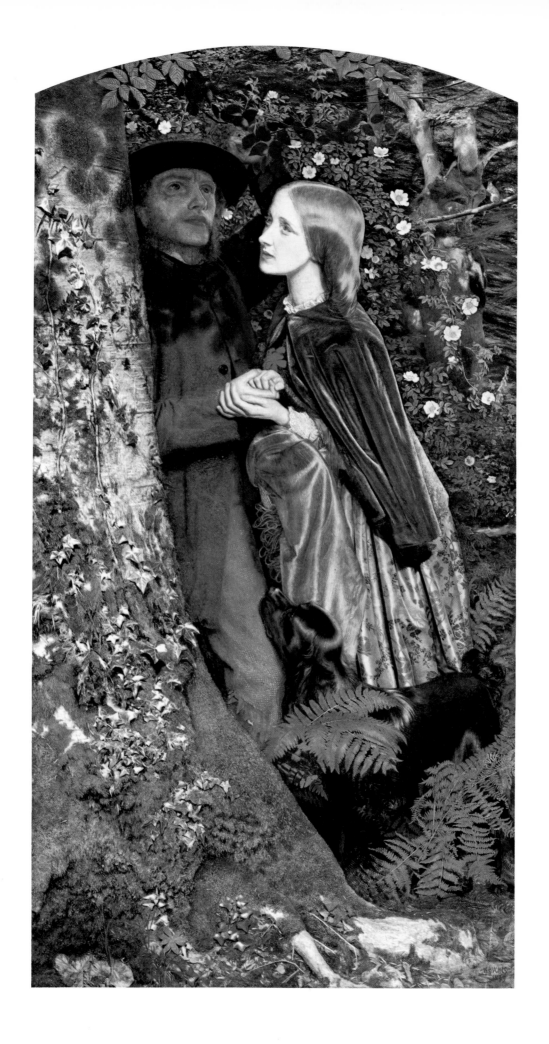

WILLIAM HOLMAN HUNT (1827-1910)
The Finding of the Saviour in the Temple

1854-60. Oil on canvas, 85.7 x 141 cm. City Art Gallery, Birmingham

Fig. 31
William Holman
Hunt
Detail from
'Nazareth'

1855. Watercolour on
paper, 35.3 x 49.8 cm.
Whitworth Art Gallery,
University of Manchester

Spurred by a desire to paint religious works of the greatest possible realism, Hunt started out on the first of four visits to the Holy Land on 16 January 1854. He made the first designs for this subject on the boat from Cairo to Damietta; when he reached Jerusalem in mid-June he made a study of the Old and New Testament sources of the story and tried to obtain Jewish models to sit for him. Some difficulties had to be overcome before the ordinances forbidding observant Jews to sit to him could be lifted, and in a letter to *The Times*, written in June 1896, Hunt told of the objectives and hindrances involved in painting this work: 'My idea was to paint the picture direct from the nature found in Palestine ... I had determined upon my subject. The meeting of St Mary with her divine Son would enable me to work on the major half of the composition without the need of women sitters, who were not to be obtained. I had settled the general features of the composition when I arrived in the Holy City ... I was able ... (after working on *The Scapegoat* [Plate 18]) with much less difficulty than before to obtain sitters, so that I again took up the Temple picture, with the happy result that I was able to complete the whole company of Rabbis and the head of St Joseph. The lines of the figure of the Saviour and the Holy Mother I had carefully expunged to save the subject from detection by the suspicious Jews, and I had used caution in speaking of it to them simply as a representation of Jews in dispute. Fever then, and a diminishing purse at the end of two years, warned me to return to England. Here I was able by the kindness of Mr Mocatta to make a tour of inspection of the Jewish schools in London, and from these I obtained the model for the boy Christ and for the Child with the fly-whisk. The other two youths were painted from a youth I had known in Jerusalem as a child and a young Hungarian Israelite found by the Rev. Ridley Herschell, father of the Lord Chancellor.'

The painting was not finished until 1860, when Hunt asked the advice of Charles Dickens on the price. Five thousand guineas was agreed upon as a reasonable recompense for the work involved. The picture was subsequently bought by Gambart for what was considered the highest sum ever paid for the work of a living painter.

Hunt began the watercolour of Nazareth (Fig. 31) in October, on his way home to England. He could spare only four days in Nazareth and worked throughout each day on it, rising before the sun rose at 5 am and finishing only after sunset. The watercolour was nonetheless unfinished, but Hunt was pleased enough with his progress: 'If I can only advance it enough', he recorded in his diary, 'it will be a great pleasure to me all my days in England.'

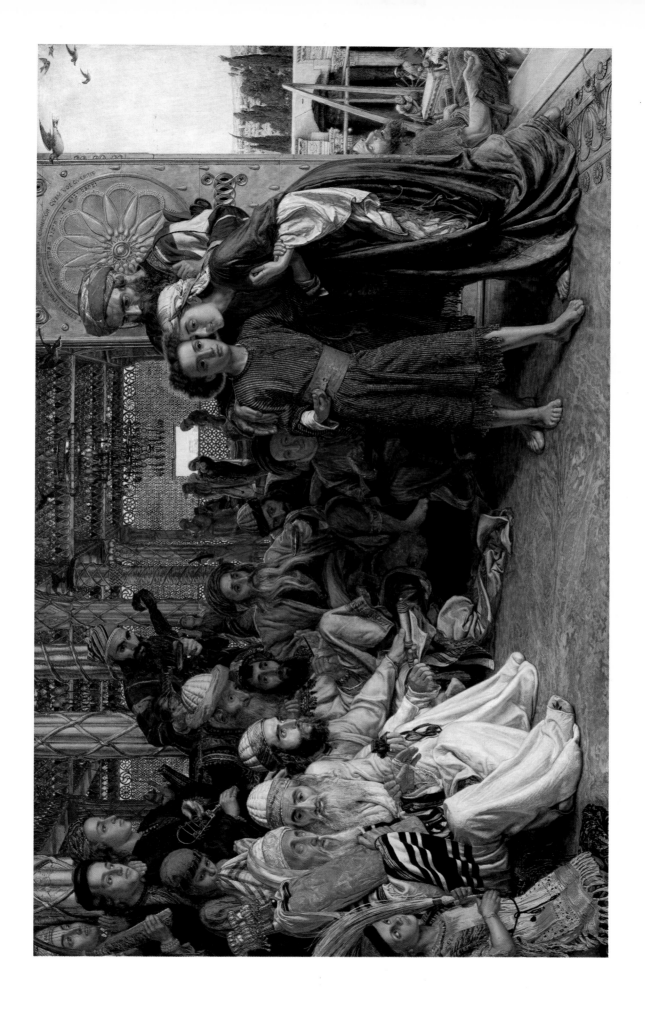

WILLIAM BELL SCOTT (1811-90)
Detail from 'Iron and Coal'

1855-60. Oil on canvas, 188 x 188 cm. The National Trust, Wallington Hall

This is the last of a series of eight large canvases designed for the central courtyard of Wallington Hall (home of the Pre-Raphaelite friend and patroness, Lady Trevelyan), illustrating subjects from Northumbrian history. The series begins with the advent of the Romans in Northumbria and ends with this scene of heavy industry in the nineteenth century. Unlike other Pre-Raphaelite paintings on the theme of labour, such as Madox Brown's *Work* (Plate 41), or Wallis' *The Stonebreaker* (Fig. 28), *Iron and Coal* is unusual in that it is devoid of ethical undertones. Although clearly influenced by *Work*, in details such as the little girl with her arithmetic book and the group of four foundry workers with their rippling musculature and raised hammers (not seen in this detail), its view is detached. The workers are not made into demi-gods or proletarian heroes, and as a result Scott has achieved an epic art of the ordinary, a contemporary subject with its own innate grandeur in the way that the heroism of antiquity had been to its own epoch. The term 'the heroism of modern life' had first been coined by Baudelaire in 1846. The Pre-Raphaelites, and certainly the French realists, attempted in their paintings of modern subjects to find an equivalent within their own times for the heroic sense of the past. Too often they became sententious or merely silly. In Scott's work, however, a genuinely epic side to modern life has been seized and portrayed with remarkable dryness and lack of pomp.

Ford Madox Brown's portrait of James Leathart (Fig. 32) shows one of the new industrial patrons for Pre-Raphaelite work. Leathart was Director of the Tyne Steam Shipping Company and of the leadworks at St Anthony's, Newcastle. He met Bell Scott when the latter was Secretary for the Art School in Newcastle, and thereafter collected a considerable number of Pre-Raphaelite works.

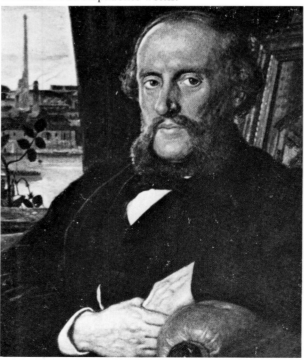

Fig. 32
Ford Madox Brown
(1821-93)
Portrait of James
Leathart

1863. Oil on canvas,
34.3 x 27.9 cm.
Private collection

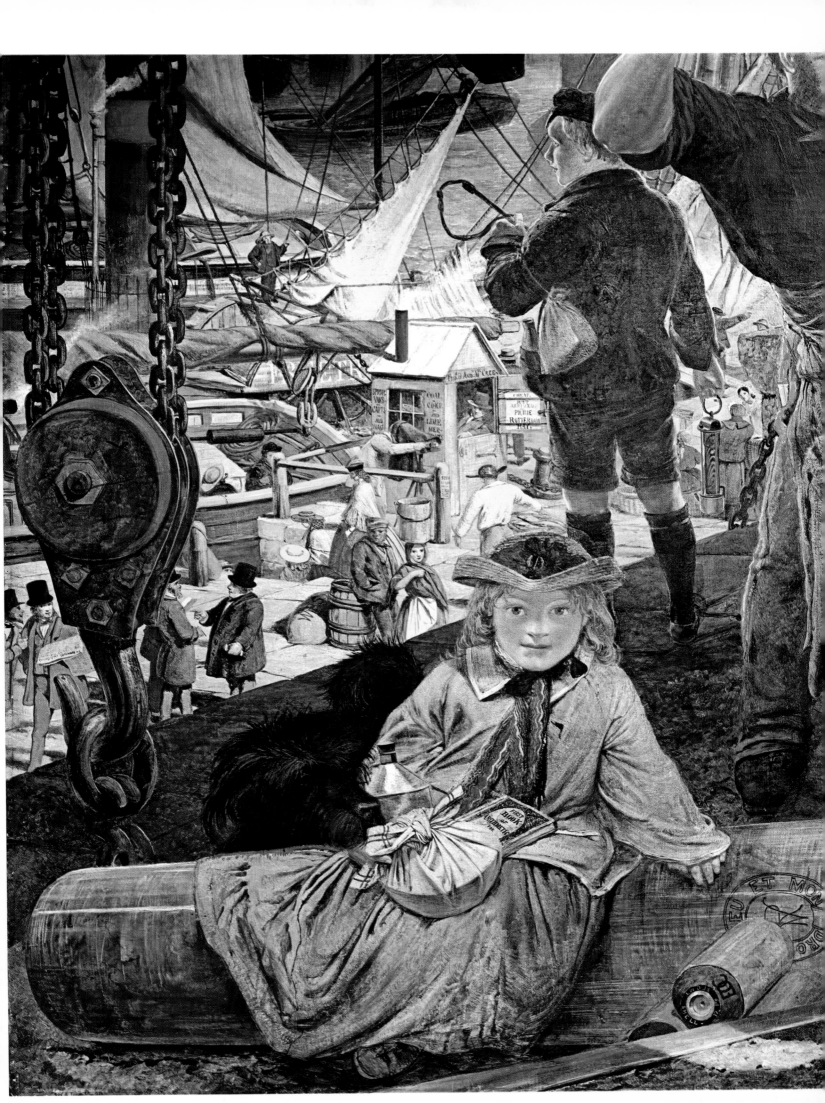

FORD MADOX BROWN (1821-93)
Walton-on-the-Naze

1859-60. Oil on canvas, 31.8 x 41.9 cm. City Art Gallery, Birmingham

Frequent references in Brown's diaries to the visual delights of the countryside show that he found landscape to be a thing of beauty in itself, and not simply a background for other subjects, as it is in the majority of Pre-Raphaelite paintings. In reference to *Carrying Corn* (Fig. 33), which he began in the autumn of 1854, he noted in August: '... out to a field, to begin the outline of a small landscape. Found it of surpassing loveliness. Cornshooks in a long perspective form, hayricks, and steeple seen between them – foreground of turnips – blue sky and afternoon sun.'

In October he noted '... one feels the want of a life's study, such as Turner devoted to landscape; and even then what a botch is any attempt to render it! What wonderful effects I have seen this evening in the hayfields! The warmth of the uncut grass, the greeny greyness of the unmade hay in furrows or tufts with lovely violet shadows, and long shades of the trees thrown athwart all, and melting away into one another imperceptibly; and one moment more, a cloud passes and all magic is gone ... It is better to be a poet; still better a mere lover of nature, one who never dreams of possession.'

The painting of Walton-on-the-Naze, a small resort on the east coast of Essex near Harwich, was begun in the autumn of 1859; Brown found it 'a place full of freshness and interest. Cliffs and ridges of clay, intercepting salt marshes ... The lady and the little girl, by their let-down hair, have been bathing – the gentleman descants learnedly on the beauty of the scene.'

Fig. 33
**Ford Madox Brown
Carrying Corn**

1854. Oil on canvas,
19.7 x 27.6 cm.
Tate Gallery, London

WILLIAM BELL SCOTT (1811-90)
Algernon Charles Swinburne

1860. Oil on canvas, 46.4 x 31.8 cm. Balliol College, Oxford

Scott and Swinburne were a curious pair of friends. Scott, the elder by twenty-six years, and a poet of minor talent, was already rigid in his thinking and full of rancour by the time he met Swinburne in the mid-1850s. Swinburne was a wild and voluble youth. His family's estate at Capheaton, Northumberland, bordered on the estates of Wallington Hall, and it was here, within the coterie of Pre-Raphaelite friends that Lady Trevelyan drew around her, that the two men met. They became friends, Scott charmed by Swinburne's brightness, Swinburne fascinated (particularly after meeting and becoming enchanted by Rossetti, Morris and Burne-Jones in Oxford in 1857) by Scott's connections with the Pre-Raphaelites. In 1858 Scott wrote to Lady Trevelyan saying he 'must have a red-haired Northumbrian' in his picture, referring to the murals he was then preparing for Wallington Hall. He did not use Swinburne finally as a model for the murals, but began to make designs for this portrait of him when the two took a trip together out to the Longstone lighthouse in 1859. Swinburne always had a passion for the sea, so it was appropriate for Scott to paint him against the Northumbrian coastline, with its big skies and strange seas. Like a fanciful creature out of Lear, Swinburne's whole being proclaims his eccentricity. Scott, with characteristic sententiousness, thought the head looked rather like that of Galeazzo Malatesta in Uccello's *Battle of Sant'Egidio*, now in the National Gallery.

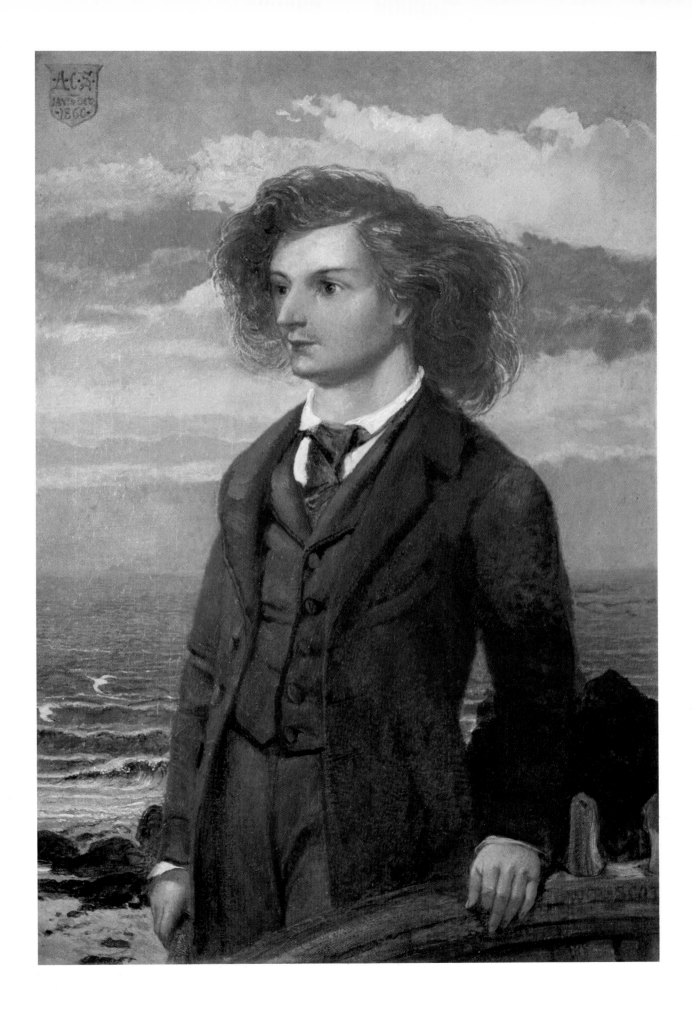

ARTHUR HUGHES (1830-1915)
The Knight of the Sun

1860. Oil on canvas, 101.6 x 132.5 cm. Private collection

Industrial magnates were the chief patrons of Pre-Raphaelite paintings. Possibly it was because they had a sharp nose for speculation, but this was not always the case, as a story told by Val Prinsep illustrates. Thomas Plint, a wealthy stock-broker from Leeds, is paying Rossetti a studio visit:

> On the easel was a charming watercolour of an 'Annunciation', the angel appearing to the Virgin in the grey dawn as she wanders by the side of a stream. The charm of the picture was the pearly grey tones of the figures and landscapes. Plint sat down before the picture. He was a Yorkshire man, and talked with a strong accent.
> 'Nobutt, Mr Rossetti,' he said, 'that's a fine thing.'
> Then, after a pause, he added: 'Couldn't you put a soonset floosh over the whole thing?'

Rossetti of course was incensed, but the painting of sunsets and dying lights was an important area of Pre-Raphaelite painting. Ford Madox Brown experimented first in *The Hayfield* (1855). Millais followed with *Autumn Leaves* (1856; Plate 22) and *Sir Isumbras* (1857). Henry Wallis brought out the eeriness of twilight in *The Stonebreaker* (1857; Fig. 28) and Hughes, in a group of paintings done around 1860, made an ambitious attempt to catch the quality of glowing embers in his sunset backgrounds. *The Knight of the Sun* is the most ambitious of these. A fiery light catches the metal of the armour, the barks of the trees, the silhouetted leaves of the sapling. The river reflects the effects of the sinking sun in much the same way that the river in Wallis' *The Stonebreaker* is gilded over. The corn stooks sit in the field looking warm. The jarring note is introduced by the all too obvious equation between the setting sun and the dying knight whose own device is that of the sun.

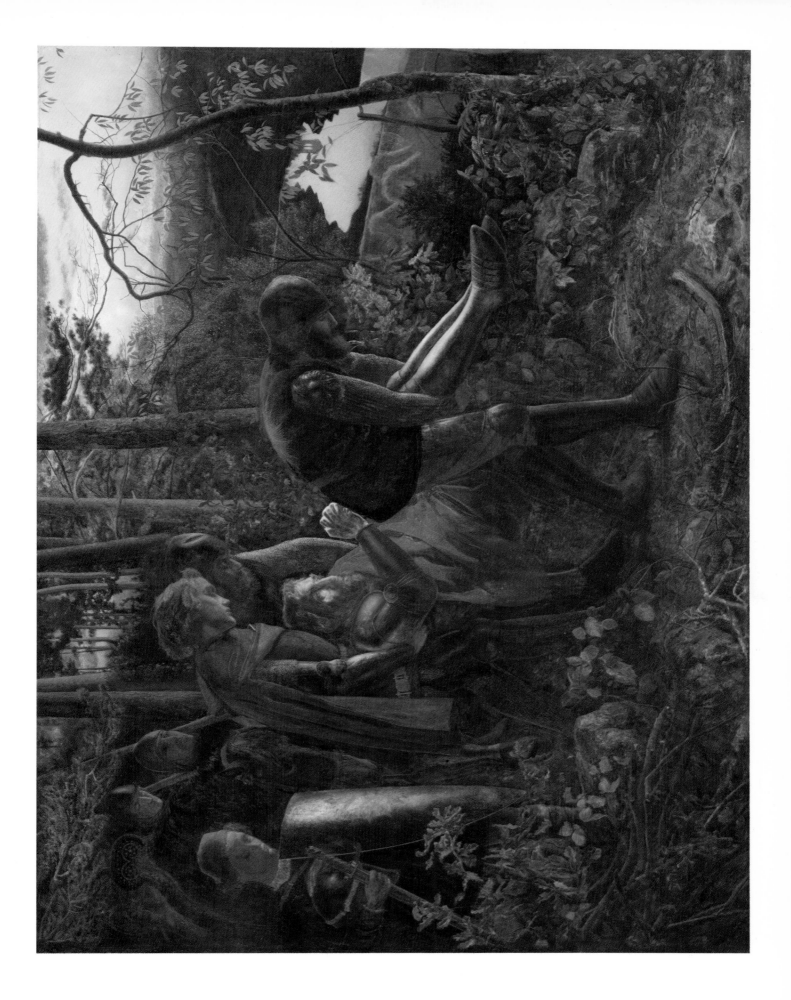

WILLIAM DAVIS (1812-73)
At Hale, Lancashire

1860. Oil on board, 31.8 x 48.9 cm. Walker Art Gallery, Liverpool

Outside London, the Pre-Raphaelites were most ardently admired in Liverpool. Every year, the Liverpool Academy hung a good proportion of Pre-Raphaelite work, and a group of Liverpool painters came directly under their influence. One of the oldest of this group was William Davis. Born in Dublin in 1812 and trained there as a portrait painter, he failed to find patronage in his native town and moved to Liverpool. He became an Associate of the Liverpool Academy in 1851 and started to exhibit landscapes there in 1853. By 1855 he had clearly come under the Pre-Raphaelite sway: the careful drawing of branches and leaves on the trees, the bright, unshaded colour, the small touch as opposed to the broad brushstroke all betray this influence. Ford Madox Brown, who saw one of his landscapes, *Wallasey Mill, Cheshire*, at the Royal Academy in 1856, wrote an admiring note on it in his diary: 'There is a little landscape by Davis, of Liverpool, of some leafless trees and some ducks, which is perfection. I do not remember ever having seen such an English landscape; it is far too good to be understood.'

With the encouragement of Brown and Rossetti, Davis was brought into the Pre-Raphaelite circle and began to exhibit regularly with them during the 1850s and 1860s. He never achieved financial success, however, partly on account of his prickly personality: he refused to have any business with dealers, which can hardly have helped his sales. Perhaps, though, as Brown said, his pictures were 'far too good to be understood'.

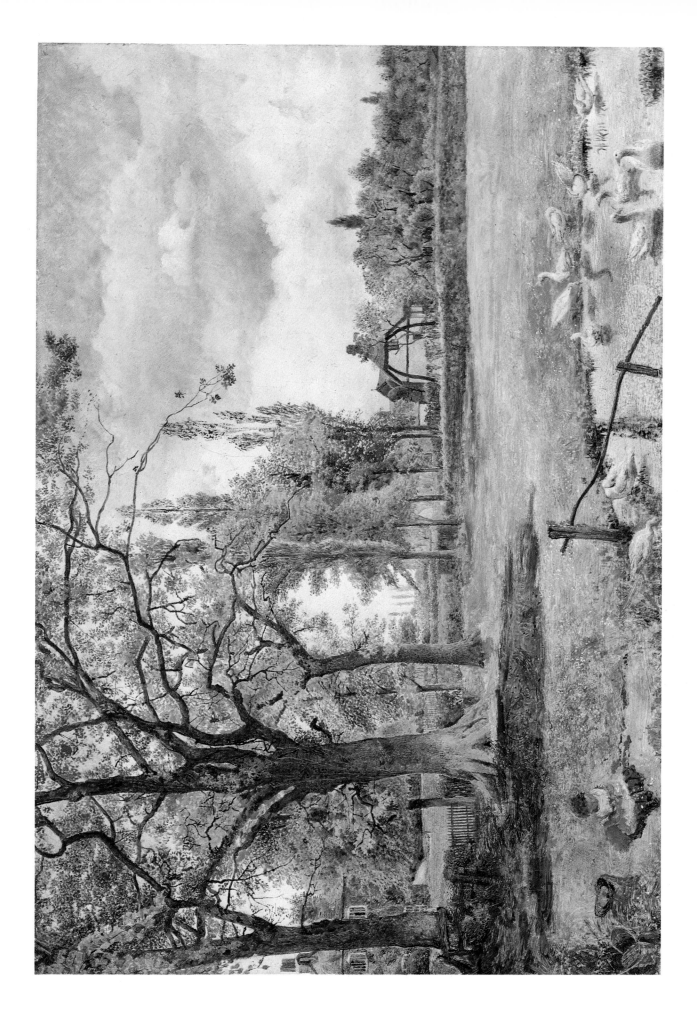

WILLIAM WINDUS (1823-1907)
The Outlaw

1861. Oil on canvas, 35.6 x 34.3 cm. City Art Gallery, Manchester

Fig. 34
William Windus
Detail from 'Too
Late'

1859. Oil on canvas,
96.5 x 76.2 cm.
Tate Gallery, London

William Windus, a Liverpool painter, produced rather dull historical subjects until he saw Millais' *Christ in the House of his Parents* (Plate 6) on exhibition in London in 1850. He was immediately converted to Pre-Raphaelitism and returned to Liverpool to paint works strongly influenced by Millais. He worked slowly, producing only two major 'Pre-Raphaelite' oils during the 1850s, *Burd Helen* and *Too Late* (Fig. 34). The latter was shown at the Royal Academy in 1859 with the following lines from Tennyson:

> ... if it were thy error or thy crime
> I care no longer being all unblest;
> Wed whom thou wilt, for I am sick of time:
> And I desire to rest.

It shows a young girl whose lover has gone away and returned again, led by a little girl, to find his sweetheart in the last stage of consumption – 'too late'. *The Outlaw* was not painted until 1861, but it employs several favourite devices of the Pre-Raphaelites – the painstakingly painted foliage, the tilting perspective which tips everything forward until it seems to drop out of the frame, the very high horizon line which presses down on the subject, making it urgent and claustrophobic. The subject itself is panic, and like most panic emanates from vague and uneasy sources. A woman crouches in the undergrowth, cradling a man's head in her arms. He has been shot with an arrow, which he limply fingers with his right hand. In the background, a bloodhound races over the heath, his nose to the ground, presumably picking up the outlaw's scent. Adverse criticism and the death of his wife in 1862 combined to undermine Windus' confidence, and he painted little thereafter. When he eventually moved to London in 1880, he burned the majority of his sketches and studies, and, as a result, there is comparatively little known extant work by him.

WILLIAM DYCE (1806-64)
George Herbert at Bemerton

1861. Oil on canvas, 86.4 x 111.8 cm. Guildhall Art Gallery, City of London

It was not surprising that Dyce should have chosen George Herbert (1593-1633), the poet and Anglican divine, as the subject of a painting. A devout Anglican himself, Dyce saw himself, like Herbert, as an artist working in the service of God. Herbert was also one of a small group of early divines whose works were praised by the Tractarian movement, and consequently his home at Bemerton, near Salisbury, was revered as an Anglican shrine. In 1860 the rector at Bemerton was Cyril Page, a close friend of Dyce, and Dyce visited him there and began work on the landscape of the painting that year. The spire of Salisbury Cathedral can be seen across the boggy grassland over the river. George Herbert stands with a book of verse in his hand, reciting out loud. As a lyric poet, a lute is made his instrument, resting by the garden wall. As a fisher of men he is complemented by the wicker fisherman's basket and the rod leaning against the tree. The fishing tackle possibly refers to Izaak Walton, Herbert's first biographer, but more celebrated as the author of *The Compleat Angler*. The deep green garden with its combination of dry and spiky topbranches and thick clumps of evergreen recall the theme of regeneration from Herbert's poem, *The Flower*:

> Who would have thought my shriveled heart
> Could have recovered greenness? It was gone
> Quite underground; as flowers depart
> To see their mother-root, when they have blown.
>
> And now in age I bud again,
> After so many deaths I live and write;
> I once more smell the dew and rain,
> And relish versing.

WILLIAM HOLMAN HUNT (1827-1910)
London Bridge on the Night of the Wedding of the Prince and Princess of Wales

1863. Oil on canvas, 65.4 x 98.1 cm. Ashmolean Museum, Oxford

The Prince of Wales (Bertie) took his bride, Princess Alexandra of Denmark, to the altar on 10 March 1863. It was the first royal wedding to be celebrated in St George's Chapel, Windsor, since the marriage of the Black Prince had taken place there in 1361. The day was made a national holiday, and festivities of all sorts were held up and down the country – bonfires, banquets and street celebrations. Hunt was in the London streets on the wedding eve, looking at the decorations. Many years later, in his published reminiscences of Pre-Raphaelitism (1905), he recorded how, 'being fascinated by the picturesque scene, I made sketches in my note-book, and the next day, feeling how inadequate lines alone were to give the effect, I recorded them with colour on a canvas. When I completed this the Hogarthian humour that I had seen tempted me to introduce the crowd; but to do this at all adequately grew to be an undertaking ... the work proved much greater than I had anticipated.' The crowd on the bridge includes many of Hunt's friends and relatives. Thomas Combe, the Printer to Oxford University, appears in the left-hand corner of the picture, with a top hat and a fluffy white beard, and with his wife at his side. Behind them, Millais' father and brother William, as well as Hunt's friend, the painter Robert Martineau, are seen perched atop a van. In the right-hand corner Holman Hunt's own profile is visible, together with a portrait of the author Thomas Hughes.

Frith's painting of the interior of the chapel showing the wedding cere-mony (Fig. 35) was commissioned by Queen Victoria for £3,000, and was painted from sittings given to the artist in his studio by the participants. Although detailed, with all the particularities of the Honiton lace veil of the Princess, and the trimming of orange-blossom and myrtle on her white satin dress, the painting cannot be described as Pre-Raphaelite. The details are illustrative, rather than dramatic, and the scene scented with the air of a fairy tale, not the smell of real life.

Fig. 35
William Powell Frith (1819-1910) The Marriage of the Prince of Wales

1863-4. Oil on canvas, 218.4 x 286.4 cm. Reproduced by gracious permission of Her Majesty the Queen

DANTE GABRIEL ROSSETTI (1828-82)
Beata Beatrix

1863. Oil on canvas, 86.4 x 66 cm. Tate Gallery, London

Elizabeth Siddal, Rossetti's wife of two years, died of an overdose of laudanum in 1862, and in the following year Rossetti began this memorial painting to her. He explained the identification of Elizabeth Siddal with Beatrice, the ideal love of Dante, in the following passage: 'The picture illustrates the *Vita Nuova*, embodying symbolically the death of Beatrice as treated in that work. The picture is not intended at all to represent death, but to render it under the semblance of a trance, in which Beatrice, seated at a balcony overlooking the city, is suddenly rapt from Earth to Heaven. You will remember how Dante dwells on the desolation of the city in connection with the incident of her death, and for this reason I have introduced it as my background, and made the figures of Dante and Love passing through the street and gazing ominously on one another, conscious of the event; while the bird, a messenger of death, drops the poppy between the hands of Beatrice. She, through her shut lids, is conscious of a new world, as expressed in the last words of the *Vita Nuova* – "That blessed Beatrice who now gazeth continually on His Countenance *qui est per omnia saecula benedictus*".'

Elizabeth Siddal was Rossetti's Beatrice, an ideal love, in whose beauty past and present, fact and symbol, death and life are reconciled. Unlike Dante's Beatrice, however, Lizzie Siddal does not stand as a symbol of Theology, but as a symbol of Art. In painting her in her moment of ecstasy, at the very point between life and death, when the passions of the body are fused with the passions of the spirit, Rossetti is making overt theological references to the Passion of Christ, to the moment when death and resurrection, damnation and redemption, merge in the single image of the crucifix. The passion of Beatrice in this painting also takes place against the form of the cross. Her body is the upright, and on either side, in the arms of the cross, stand the figures of Love and Dante. Rossetti paints passionately here, affirming that, both as a testament to the memory of his wife and to the mysticism of Dante's world, the spirit of Art transcends mortality as the spirit of Theology transcends the flesh.

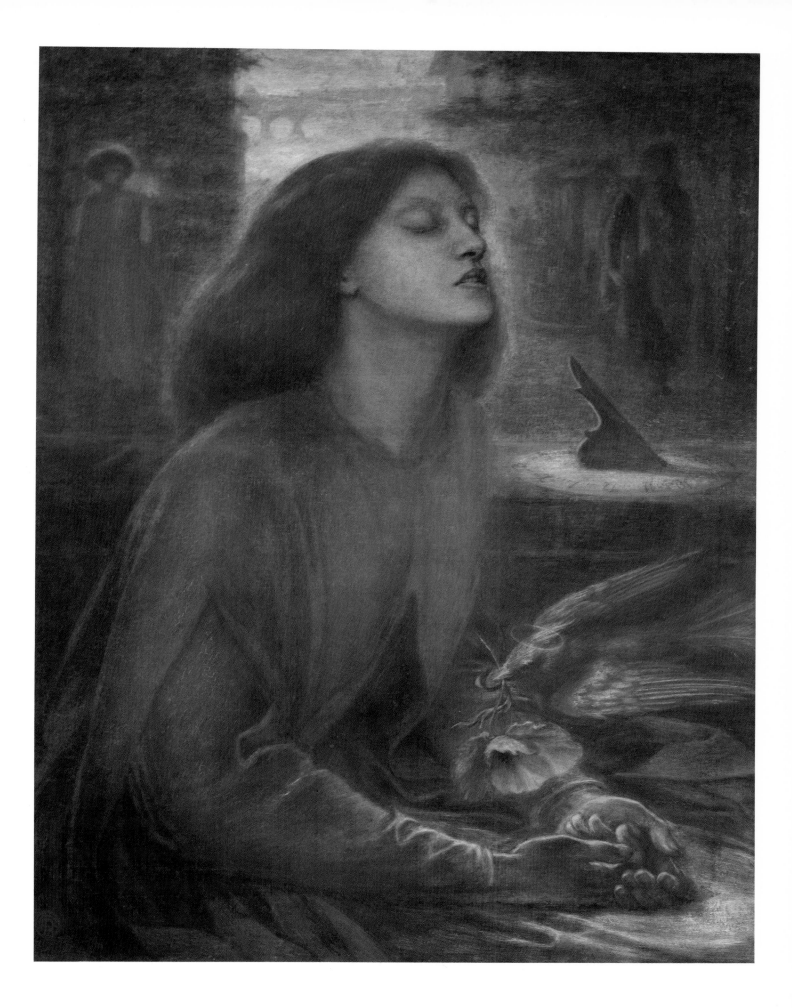

FREDERICK SANDYS (1832-1904)
Morgan-le-Fay

1864. Oil on panel, 62.9 x 44.5 cm. City Art Gallery, Birmingham

Ironically, Sandys became friendly with the Pre-Raphaelite group after he had made an attack on them in 1857 through the publication of a satirical print, *A Nightmare*, in which he parodied the mannerisms and medieval pastiche found in much of their work. He became particularly friendly with Rossetti, working in his studio in Cheyne Walk for a year in the mid-1860s. As a draughtsman he was infinitely superior to Rossetti, and in fact was among the finest English draughtsmen of the late nineteenth century. On an imaginative level, however, he was the poorer artist, and the rather thin imaginative atmosphere of his paintings is frequently clothed in an elaborately detailed outer cloak, so that one is dazzled by the surface brilliance of his paintings and momentarily forgets the inner paucity. This is the case with *Morgan-le-Fay*, where the theme is sorcery, but the treatment so explicit that any sense of the magic is stifled. Morgan-le-Fay was the half-sister of King Arthur. She was jealous of Arthur's goodness and his capacity for inspiring love and so plotted to kill him. In Sandys' painting, she is seen standing with her back to the loom on which she has woven an enchanted garment for Arthur, a mantle which will consume his body with fire. She has hung the garment over a cabinet so that she can examine her handicraft properly, by the light of a lamp. Symbols of necromancy form a border round the hem of her dress, and occult texts, potions, and jars of curious liquids lie at her feet. A cloth with the heads of fantastic beasts lines the far wall of her chamber.

FORD MADOX BROWN (1821-93)
Work

1852-65. Oil on canvas, 137.2 x 197.5 cm. City Art Gallery, Manchester

The distribution of labour in a newly industrialized society is the theme of this complex pictorial image. Begun in 1852, about half-way up Heath Street, Hampstead (Fig. 36), it illustrates, as Rossetti said, 'all kinds of Carlylianisms'. Carlyle himself stands with a stick in hand on the right of the picture. He and F.D. Maurice represent intellectual effort. The group of navvies in the centre represents different types of instinctual physical life: 'Here are presented', wrote Brown in 1865, 'the young navvy in the pride of manly health and beauty; the strong fully developed navvy who does his work and loves his beer; the selfish old bachelor navvy, stout of limb, and perhaps a trifle tough in those regions where compassion is said to reside; the navvy of strong animal nature ... Then Paddy with his larry and his pipe in his mouth.' Aligned along the left of the picture are those who for different reasons do not know the full meaning of work. The beggar has never been taught to work; the rich, on horseback, have no need to tread the daily mill of activity, the two married ladies between the beggar and the rich are supported by husbands, and can therefore indulge in distributing religious tracts, as one of them does, or simply in dressing beautifully, as does the younger of the two. On the right, in the background, various idlers have been impressed into the service of Bobus to carry his election boards. Bobus is a character from Carlyle's *Past and Present*, 'the sausage-maker of Houndsditch', who made a fortune by introducing horsemeat into England as cheap food and now intends to stand for Middlesex, to represent those whom he has exploited. Another self-made man appears in the figure of the beer seller, 'hump-backed, dwarfish, and in all matters of taste, vulgar as Birmingham can make him look in the 19th century', but plying his trade lustily among the navvies. His black eye shows what kind of man he is when work is over. Even academic pretension is given a sly tweak by Brown in this painting through his introduction of the Assembly-room of the 'Flamstead Institute of Arts' in the distance, where, as Brown noted in his catalogue, 'Professor Floox is about to repeat his interesting lecture on the habits of the domestic cat. Indignant pusses up on the roof are denying his theory in toto.'

Fig. 36
Ford Madox Brown
Heath Street,
Hampstead

1852-5. Oil on canvas,
22.8 x 30.8 cm. City Art
Gallery, Manchester

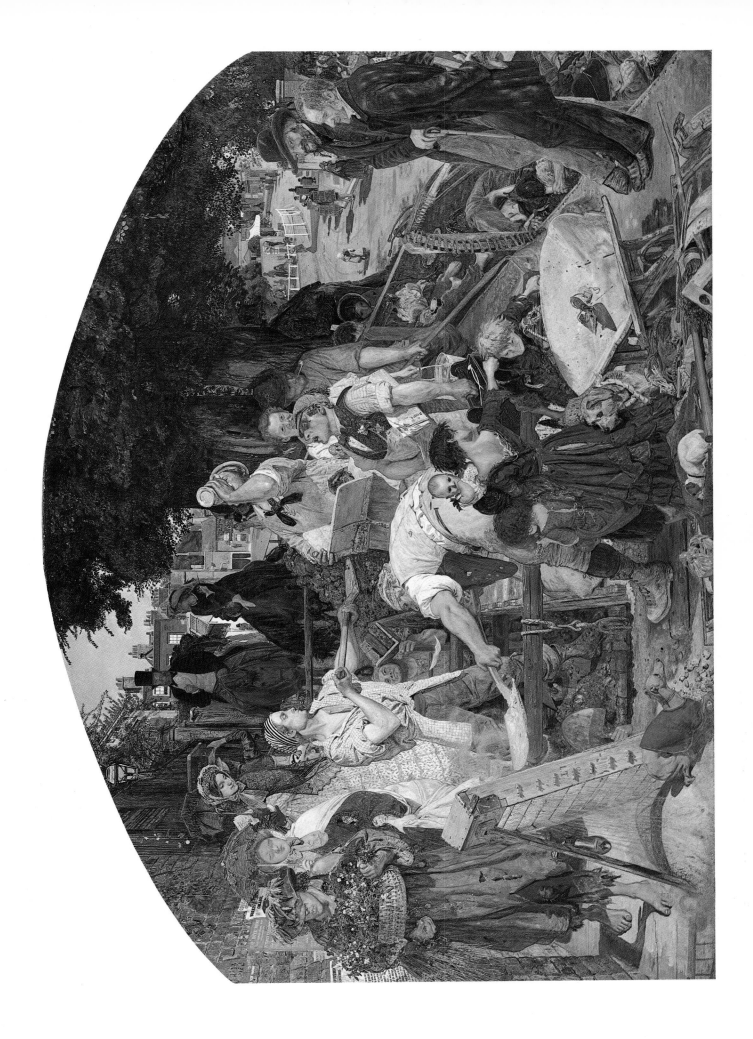

JOHN BRETT (1830-1902)
February in the Isle of Wight

1866. Watercolour on paper, 40 x 35.2 cm. City Art Gallery, Birmingham

A trip to Switzerland in the summer of 1856 was the turning-point in Brett's career. It was 'there and then', he declared, '[I] saw that I have never painted in my life, but only fooled and slopped, and thenceforward attempted in a reasonable way to paint all I could see.' Until this date, Brett's output had fallen neatly within the conventions taught at the Royal Academy schools, which he had entered as a pupil in 1854. From this date, however, his work was typified by the most minute rendering of natural detail, scientific in its precision and its detachment. Brett's eye was like a scientific instrument, taking in every recordable visual fact that came within its scope, but with no register for sentiment. In later years he became a Fellow of the Royal Astronomical Society. Criticizing an early work, *Val d'Aosta* (1859), Ruskin laid his finger on the problem affecting nearly all of Brett's detailed views: 'It has a strange fault, considering the school to which it belongs — it seems to me wholly emotionless. I cannot find from it that the painter loved, or feared anything in all that wonderful piece of the world ... Keeness of eye and fineness of hand as much as you choose; but of emotion, or of intention nothing traceable ... He has cared for nothing, except as it was more or less pretty in colour and form. I never saw the mirror so held up to nature; but it is Mirror's work, not Man's.' The mirror was certainly in operation in *Florence from Bellosguardo* (Fig. 37), painted between 1862 and 1863 from the Villa Brichieri, the home of Isa Blagden and watering-hole of the English literati then living in Florence. In *February in the Isle of Wight*, painted in 1866, the chill February light gives the scene a certain airless aridity, as if it were being viewed under ideal laboratory conditions. The heat of feeling is eliminated. Brett's scientific curiosity has carried the day.

Fig. 37
**John Brett
Florence from
Bellosguardo**

1862-3. Oil on canvas,
59.7 x 100.3 cm.
Tate Gallery, London

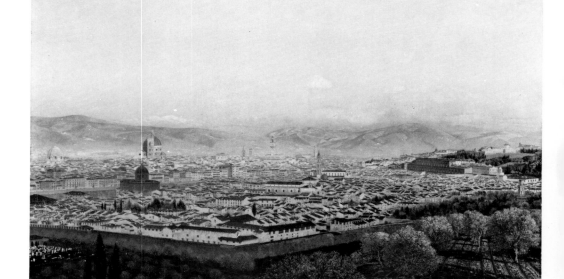

43 EDWARD BURNE-JONES (1833-98)
Phyllis and Demophoon

1870. Gouache on paper, 91.5 x 45.8 cm. City Art Gallery, Birmingham

The story of Phyllis and Demophoon is taken from Ovid's *Heroides* and relates how Phyllis, Queen of Thrace, fell in love with Demophoon, son of Theseus and Phaedra, when he stayed at her court on his return from the Trojan War. He stayed in Thrace several months, and on sailing for Athens, promised to return to Phyllis within a month. He did not return, however, and the gods eventually took pity on the distraught queen by transforming her into an almond tree. When Demophoon finally returned to Thrace and heard of Phyllis' fate he ran to embrace the barren tree, which burst into blossom, momentarily turning back again into the form of the lovelorn queen. The model for Phyllis was Maria Zambaco, a Greek beauty living in London, with whom Burne-Jones was in love from 1867 to 1870. Possibly his choice of subject contains some private allusion to their relationship, which by 1870 was on the verge of collapse. Certainly the subject caused him to break with the Old Water-Colour Society, where Burne-Jones first showed this work in 1870. Several members of the society objected to the nudity of Demophoon and asked him to drape the figure more decorously. Burne-Jones refused, withdrew the picture and resigned from the society.

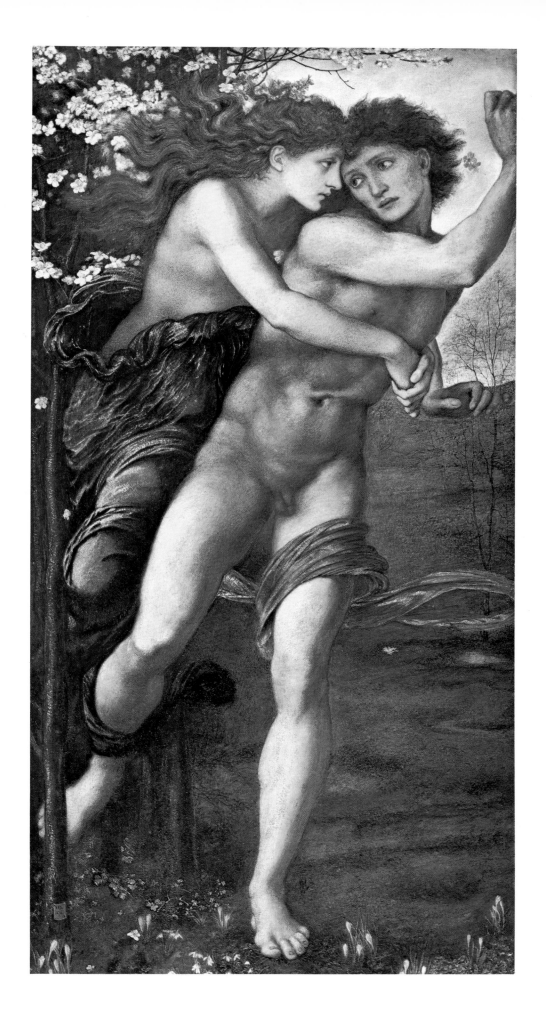

DANTE GABRIEL ROSSETTI (1828-82)
The Blessed Damozel

1871-7. Oil on canvas, 174 x 94 cm. Fogg Art Museum, Cambridge, Massachusetts

The blessed damozel leaned out
From the gold bar of Heaven;
Her eyes were deeper than the depth
Of waters stilled at even;
She had three lilies in her hand,
And the stars in her hair were seven.

'I wish that he were come to me,
For he will come,' she said.
'Have I not prayed in Heaven? – on earth
Lord, Lord, has he not pray'd?
Are not two prayers a perfect strength?
And shall I feel afraid?'

Rossetti first wrote 'The Blessed Damozel' in 1847, but the poem appeared with different revisions in 1850, 1856, 1870 and 1881. It was clearly a theme that preoccupied him throughout his life, and one which, he claimed, was inspired by Edgar Allan Poe. Poe, he said, 'had done the utmost it was possible to do with the grief of the lover on earth, and so I determined to reverse the conditions, and give utterance to the yearning of the loved one in heaven'. The theme of the discontented lover in heaven has not only sacrilegious overtones but macabre ones. Rossetti's maiden leans out of her balcony in heaven while behind her newly reconciled lovers embrace one another among the deathless roses of heaven. She sees her lover lying fully corporeal on earth and yearns for his death, so that he may join her for ever in heaven. United in and beyond the grave, these lovers demonstrate a curious rebellion against mid-Victorian ideals of heavenly peace. The rebellion was declared loudest in that most Pre-Raphaelite of all literary works, *Wuthering Heights*. 'Heaven did not seem to be my home,' weeps Catherine Earnshaw to Nelly, 'and I broke my heart with weeping to come back to earth.' For both Brontë and Rossetti the complacent trust in the mid-Victorian idea of heaven was a thing to be challenged.

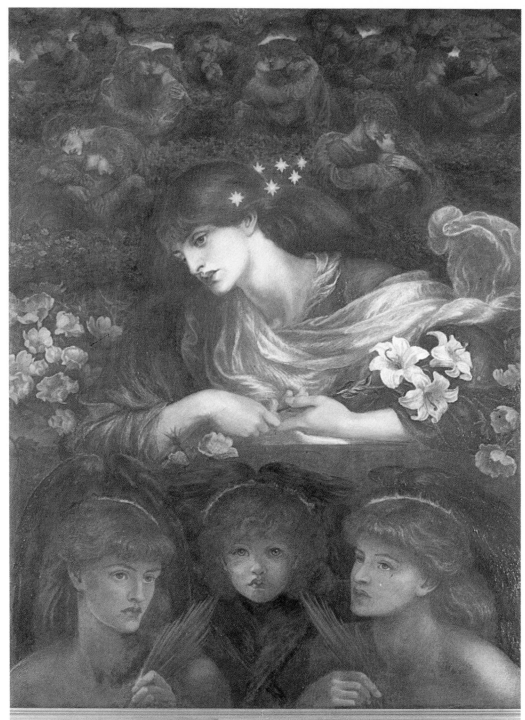

THE BLESSED DAMOZEL

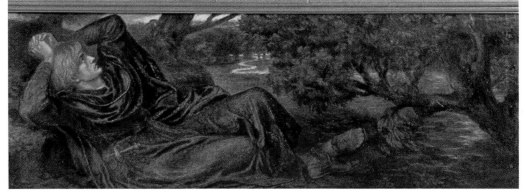

EDWARD BURNE-JONES (1833-98)
The Arming of Perseus

1877. Tempera on canvas, 152.4 x 127 cm. Southampton Art Gallery

The Rt Hon. Arthur Balfour commissioned a series of decorative paintings from Burne-Jones in 1875 for his London house at 4 Carlton Gardens. Burne-Jones selected the Perseus legend, and originally intended to treat the whole legend of the doom of King Acrisius. The complete scheme, however, was never carried out, but ten full-scale gouache cartoons are in existence at Southampton Art Gallery, of which this study, *The Arming of Perseus*, is one. Perseus was the issue of Danaë's union with Jove. Danaë's father, Acrisius, King of Argos, had been warned by an oracle that his daughter's son would one day slay him. He therefore locked her up in a brazen tower to prevent her making alliances with men, but it was here that the god Jove seduced her. After Perseus' birth, both she and her son were cast adrift on the open sea by Acrisius, coming ashore finally on the island of Seriphos. Perseus grew up here and later set out to capture the head of Medusa, the Gorgon in whose sight men were turned to stone. In this scene, Perseus has found his way to the cave of the sea-nymphs who will give him the armour he needs to protect him against the Gorgon. One of the nymphs holds out a helmet that will render him invisible. Another offers him the winged sandals of Hermes, a third holds the pouch in which the Gorgon's head is to be carried. Burne-Jones designed much of the armour for this series himself: 'The purpose', he declared, 'is to lift it out of any historical period.' It is interesting to compare the imaginative suit of armour Perseus wears with that of Valentine in Hunt's *Valentine Rescuing Sylvia from Proteus* (Plate 9), which is probably one of the most accurately observed and carefully painted suits of armour in English painting of any period.

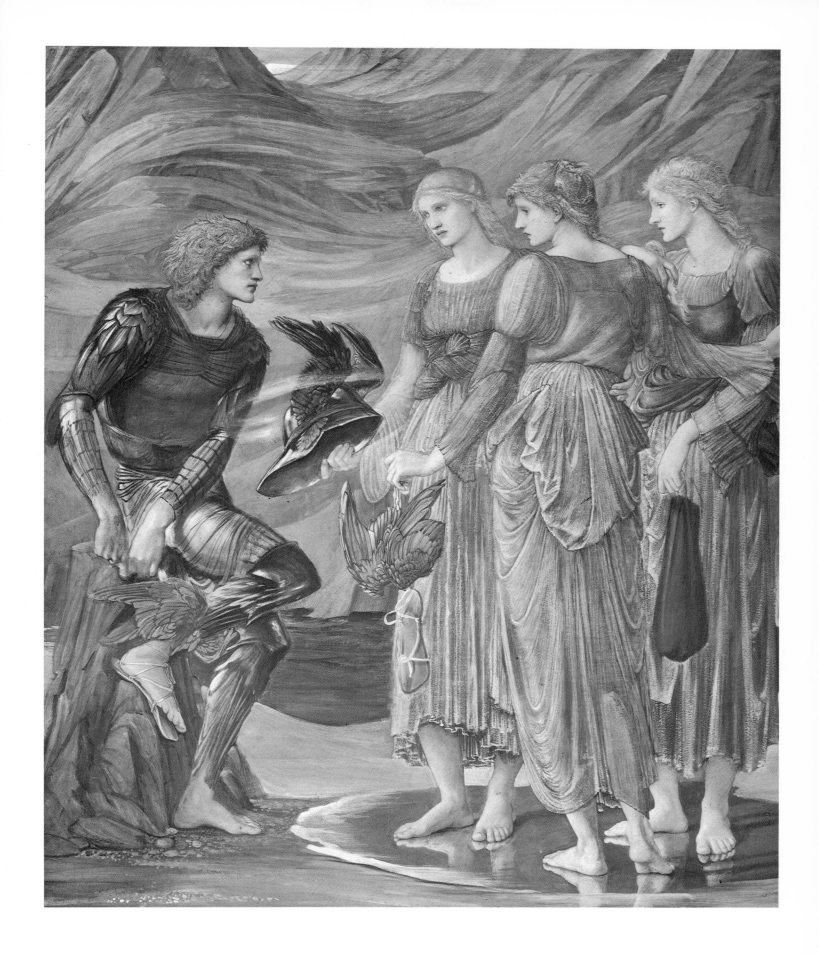

EVELYN DE MORGAN (1855-1919)
Flora, the Goddess of Blossoms and Flowers

c.1880. Oil on canvas, 198 x 88.3 cm. De Morgan Foundation Collection

Evelyn de Morgan, née Pickering, was the niece of Spencer Stanhope, one of the painters selected by Rossetti to work on the Oxford Union Murals in 1857 and a Pre-Raphaelite follower. Evelyn studied at the Slade in 1873 and visited Italy between 1875 and 1877 where she was greatly impressed by the work of Botticelli. In 1885 she married William de Morgan (1839-1917), an intimate of the Pre-Raphaelite circle and a designer of stained glass and tiles for Morris and Co. He disliked the way his designs were reproduced by Morris' firm, and set up a kiln in his own home, rediscovering the forgotten art of lustre decoration for pottery (Fig. 38). More than perhaps any other craftsman of the period, he broke down the lines dividing the fine arts from the applied arts, giving his wares the status of 'art pottery'. One is tempted to see the same process in reverse in the paintings by his wife, which are pretty and decorative in the way one usually associates with the applied, rather than the fine, arts.

Fig. 38
**William de Morgan
(1839-1917)
Earthenware Dish**

c.1880. Painted in ruby
lustre. Victoria and Albert
Museum, London

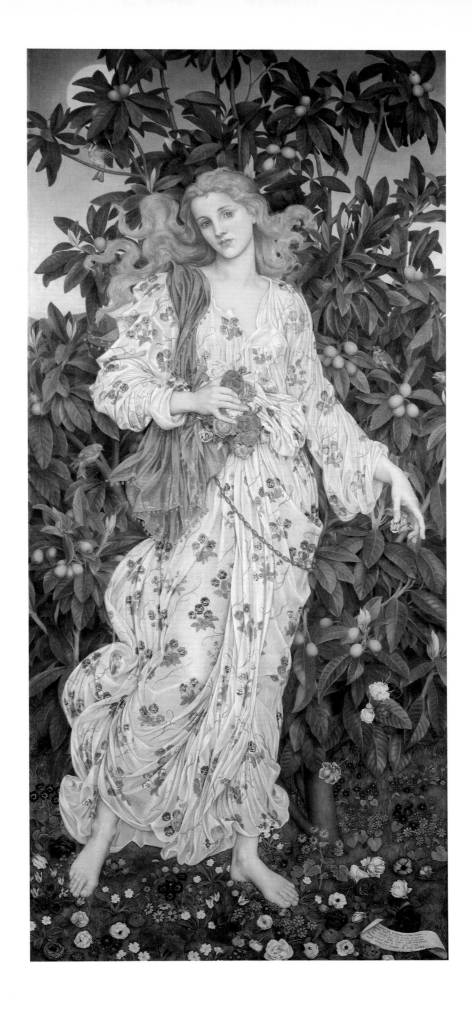

JOHN MELHUISH STRUDWICK
(1849-1935)
The Gentle Music of a Byegone Day

1890. Oil on canvas, 79.1 x 61.3 cm. Private collection

'One wonders', mused George Bernard Shaw in 1891, 'how this sordid nineteenth century of ours could have such dreams, and realise them in its art.' He was writing about the work of John Melhuish Strudwick, and continued by declaring: 'Transcendent expressiveness is the moving quality in all Strudwick's works; and persons who are fully sensitive to it will take almost as a matter of course the charm of the architecture, the bits of landscape, the elaborately beautiful foliage, the ornamental accessories of all sorts, which would distinguish them even in a gallery of early Italian painting.' Strudwick had been an unsuccessful student at the Royal Academy schools, and it was not until he met Burne-Jones and became his studio assistant that he found his true strength. Like the work of Burne-Jones, Strudwick's paintings (Plate 47 and Fig. 39) are principally decorative, designed to be beautiful and poetic. Unlike that of Burne-Jones, it is always impeccably drawn, with an architectural precision of detail, and with little real understanding of the significance of the myths and legends upon which it draws. For this reason, his images of bygone days look more like tableaux of well-bred girls from St John's Wood in fancy-dress than they do of the romance and poesie of latterday. Good breeding and exquisite cultivation of exquisite emotions seem the main point of these decorative images. It was Henry James, rather than Bernard Shaw, who was the more acute critic about this sort of painting when he complained that 'it is the art of culture, of reflection, of intellectual luxury, of aesthetic refinement, of people who look at the world not directly, as it were, but in the reflection and ornamental portrait of it furnished by art itself'.

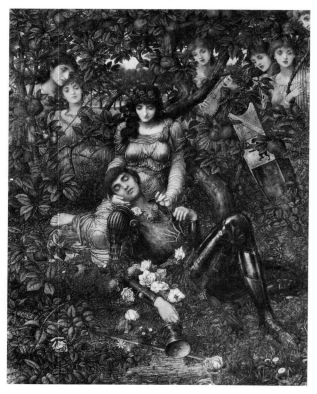

Fig. 39
John Melhuish
Strudwick
Acracia

c.1888. Oil with gold on
canvas, 71.7 x 57.1 cm.
Private collection

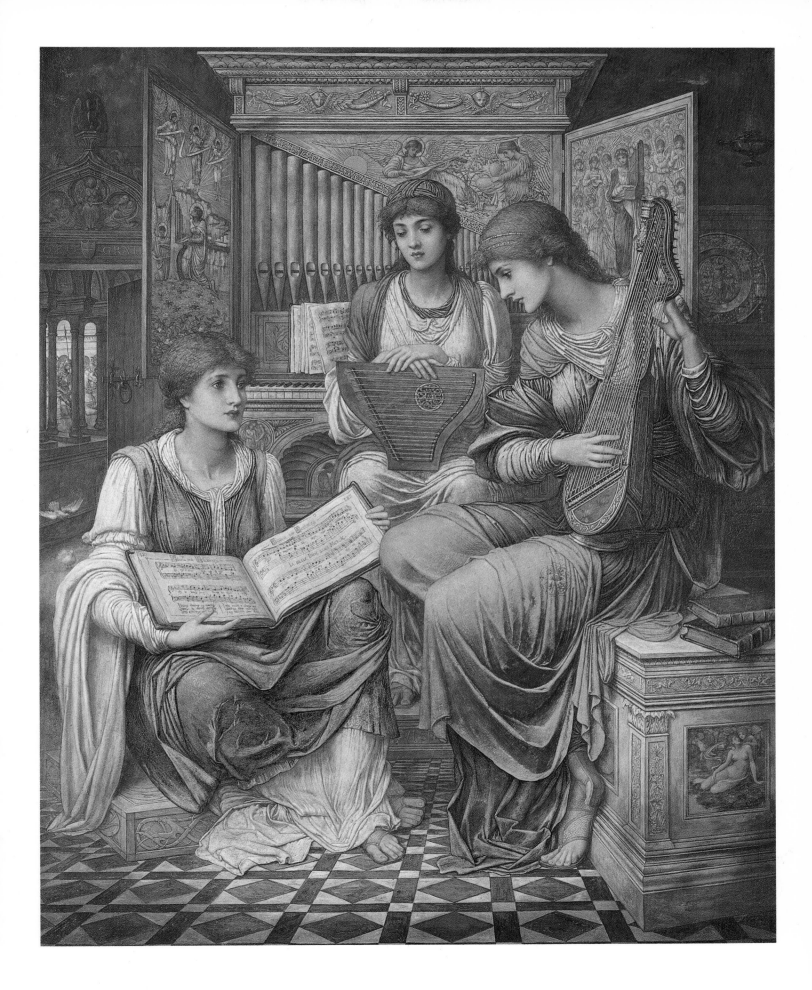

JOHN BYAM SHAW (1872-1919)
The Boer War

1901. Oil on canvas, 100 x 74.9 cm. City Art Gallery, Birmingham

John Byam Shaw is an example of a painter influenced by Pre-Raphaelitism long after its main impetus had died away. *The Boer War* was exhibited at the Royal Academy in 1901 with the following lines from Christina Rossetti:

> Last summer green things were greener
> Brambles fewer, the blue sky bluer.

In many respects the painting is an elegy for the expiring spirit of the movement. The painting of the natural setting, where the drawing and colouring are clear, and every leaf and blossom stands out separate and precise, harks back to the techniques employed by Hughes, Hunt and Millais half a century earlier. At that time, however, the fervour to paint that way had been inspired by a quasi-religious belief in the regenerative and moral power of art. During the decades which followed, that belief had given way and by the 1890s much of the faith formerly placed in art had dissolved and been reabsorbed in the spectacular rise of imperialist sentiment. A unified British Empire now took on the quality of a religious ideal in the midst of such national crises as the Jameson Raid (1895), the Fashoda incident (1898) and the Boer War (1899-1900). The figure in Byam Shaw's painting stands out from the background like a photomontage, and in a way the sentiment of his painting — that of wistful reflection — stands isolated from the main sentiment of the day — a heavy political activism that regarded events such as the Boer War as positive encouragement for freedom and creativity. The Pre-Raphaelites had not succeeded in arresting the separation of art from the other areas of activity — social, religious, moral. In fact, by 1900, they had collaborated in its isolation to a large degree. Byam Shaw's painting, with its beautiful surface, its melancholy and its inbred langour, is as isolated in its political comprehension as it is from the grim realities of war (Fig. 40).

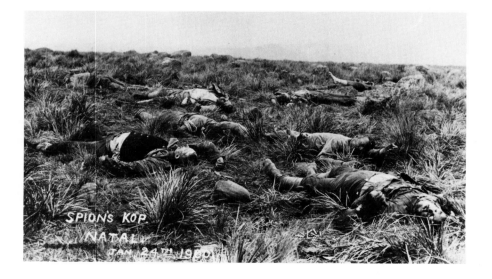

Fig. 40
Photograph of the Dead in the Boer War

National Army Museum, London